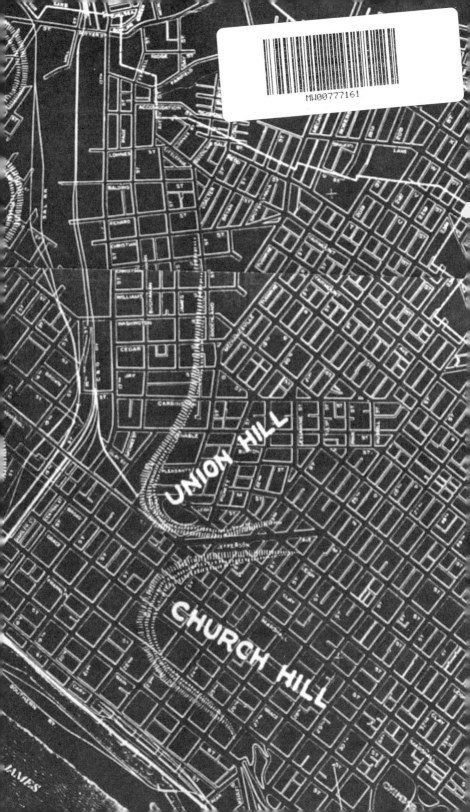

# Dedication

*This book is dedicated to my father,*
*who taught me how to write,*
*my mother,*
*who taught me how to dream, and*
*my wife,*
*who taught me how to put them together.*

-Brooks Smith

# Facts and Legends
## of
## The Hills of Richmond

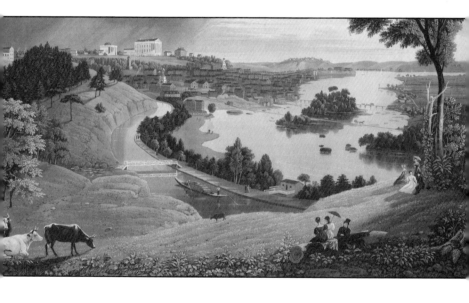

Co-Authors
Brooks Smith & Wayne Dementi

Foreword By
Dr. Charles F. Bryan, Jr.

ISBN 978-0-9773153-8-3

Brooks Smith & Wayne Dementi
Co-authors
2008 Second Printing

For information write:

Dementi Milestone Publishing
1530 Oak Grove Drive
Manakin-Sabot, VA 23103

dementi@aol.com or (804) 784-5151

Graphic designer:
Pam Bullock, Graphics Custom Designed

Cover image:

**Richmond, from the Hill above the Waterworks.**
Engraved by William James Bennett from a painting by
G. Cooke.  Acquired for this book from the
Library of Virginia.

# Table of Contents

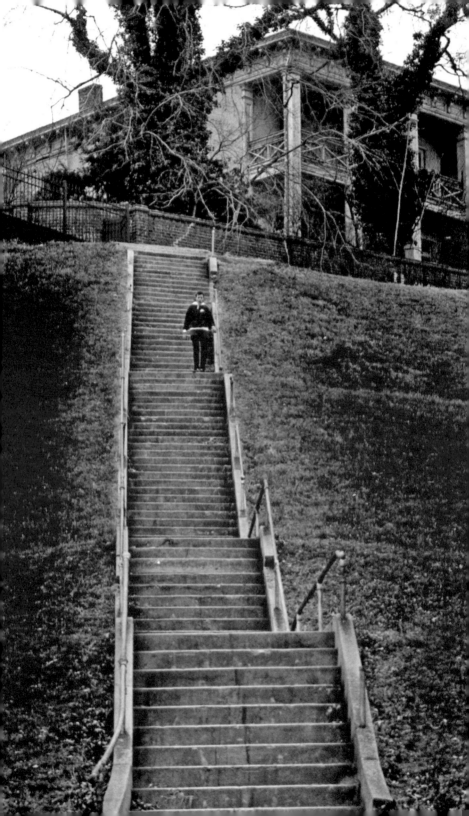

# Foreword

With the emergence of the New South in the last half of the twentieth century, many Richmonders have looked with envy at other southern metropolitan areas that have "moved ahead" of their city. Somehow in the minds of these people, Charlotte, Atlanta, Raleigh, Orlando, and Nashville seem to have it all. Poor Richmond has been left behind in the collective dust of their "progress."

Dr. Charles F. Bryan, Jr.

Yet if you were to ask Richmonders if they would want their city to be more like those others, most would probably respond with a resounding "no." They prefer Richmond's lighter traffic, its beautiful setting on the James River, its close proximity to the ocean and mountains, and its smaller size. Also, I wouldn't be at all surprised if proud Richmonders boasted that their city wins the competition hands down when it comes to history. Indeed, a few years ago, a group of civic boosters proclaimed Richmond "America's most historic city." While Boston, Philadelphia, and New York City might challenge that assertion, there is no denying that Virginia's capital has a long and rich history, one that few cities can match. I never cease to be amazed, however, at the new things we learn about its past.

I am delighted that Brooks Smith and Wayne Dementi have helped bring many new aspects of Richmond's history to light in **Facts and Legends of the Hills of Richmond**. Drawing on the remarkable collection of new and historic photographs from the Dementi Family of Photographers, the **Richmond Times-Dispatch**, the Virginia Historial Society, the Valentine Richmond History Center, and other worthy sources to illustrate a lively narrative, the authors have produced a volume that will interest all Richmonders, whether they are life-long residents or newcomers.

Anyone reading **Facts and Legends** will better understand why Richmond is such a special city because of, among other things, its fascinating past. I salute Brooks Smith and Wayne Dementi for sharing their unique perspectives on Richmond both in words and through dozens of fascinating photographs.

> Dr. Charles F. Bryan, Jr.
> President & CEO
> Virginia Historical Society

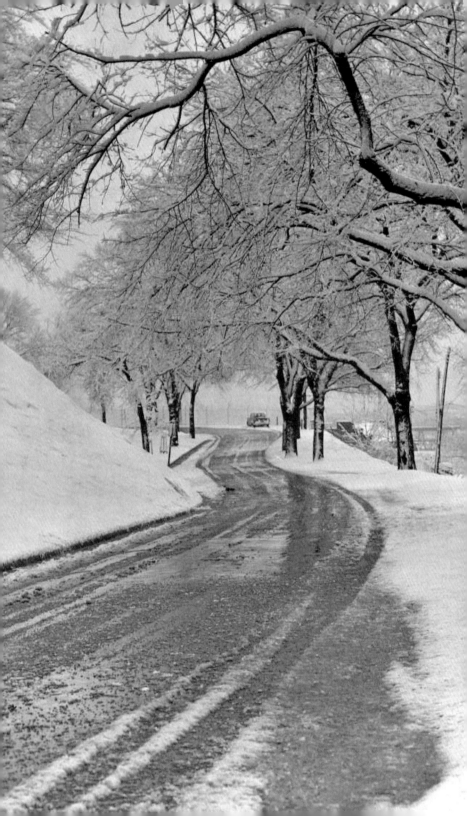

# Preface

Like a dowager queen concealing her fading beauty behind curtained windows, Richmond waits, contemplating her often splendid, sometimes misspent, youth. Oh, the stories she could tell if only someone would listen.

Brooks Smith listens.

Since volunteering in September 2005, Brooks has written and delivered some 40 commentaries on WCVE Public Radio under the working title "Rediscovering Richmond." He has spent countless unpaid hours in the public library, musing musty files, records, and newspaper clippings from bygone eras. Fair to say, he fell in love with his adopted city, which he calls his Muse.

Wayne Farrar

On the whole eschewing the familiar history of a capital of revolution and secession, Brooks searched out long forgotten tales – of neighborhoods before they were bisected by expressways, of streetcars, desperados, and sturgeon in the James.

He found a link between the Haitian slave revolution and Gabriel's Rebellion. He convincingly suggested that Richmond's literary genius, Edgar Allan Poe, had a part in naming mysterious Chimborazo Hill.

A lawyer by profession, his essays show the tenacity of a historian, the curiosity of a journalist, and the soul of a poet.

A surprising number of the stories he unfolded have a connection to one of the city's hills – which he points out do not number seven, as myth would have it.

Illustrated by new and vintage photographs from the Dementi family collection, **Richmond Times-Dispatch**, Virginia Historical Society, Valentine Richmond History Center, and promising newcomer Richard Page, **Facts and Legends of the Hills of Richmond** compiles more than a score of Brooks' radio essays into a volume any Richmonder, whether FFV or come-here, would treasure. Brooks calls his work an adventure and recommends an adventurer's attitude to others who would rediscover Richmond. His adventure has just begun.

Wayne Farrar
News Director, WCVE Public Radio
Local Anchor-Editor, Morning Edition

# Dedicated to our parents
# Frank & Connie Dementi

*Whose lives together in business spanned over 40 years*
*of photographing people and places of Virginia*
*as newspaper/professional photographer*
*and business woman*
*and as owners of Frank Dementi's Colonial Studio.*
*We are pleased to share several photos*
*from their collection in this book.*

*With love,*
*Brian Dementi and Wayne Dementi*

# Photographer's Observations

By
Wayne Dementi

Richmond is known to be a
photogenic city. We are steeped
in history and all of its imagery.
We have some of the nation's most
recognized architecture lining
our streets. We have America's
Founding River, the James, run-
ning through it. And, we have
hills... beautiful, rolling hills.
Seven like Rome, as our early
accounts would say. Happily, we
now know there are many more.

Our hills have served to offer the picturesque setting for the
many stories that have shaped our collective personality.
Capitol Hill, our most Rome-like hill, is certainly an appro-
priate place to begin our journey. Jeffersonian architecture,
rolling landscape, and a remarkable history characterize this
hill, and its place in our hearts.

My Dad, who made a career out of photography, had a spe-
cial eye for Richmond's beauty. He loved to photograph our
people doing their thing, and he had a particularly good way
of capturing expressions that revealed the proud relation-
ship of Richmonders to Richmond. I was blessed to follow
him around, carry his camera bag, and witness these things.
I have drawn from these early experiences in selecting, or
personally capturing, images for this book. It is my wish that
you will smile, and beam with pride, as you turn these pages.

# Introduction

**R**ichmond is my Muse. She is beauty suspended. And in the first light of day or the dying embers of night, she croons wild old stories that are neither here nor there but somewhere in between, almost impossible to believe but tantalizingly close, like the first discoveries of childhood along a river roiling with adventure.

Richmond is an irregular place, impossible to explain except by stepping into the shoes of her past and walking apiece, over old cobbles and trestles, past haunts and hidden alleys, down by the old locks and dams, and then up again, always up, like Phoenix rising from the ashes, moderately well-behaved but still a touch wild, untrammeled, like a story just preening to be told.

Richmond is Paradise, neither flat nor peaked, but hilly. So much better to draw us up from the troughs and pitch us, rolling like children, over the top. She is a perch above the fray, a place to ponder the contours of our sweetly crooked paths.

To be sure, Richmond is elusive too, like the seabed exposed or the sky upturned, each cloud a little summit that wisps away before our eyes.

For many years, we laid claim to the notion that Richmond, like Rome, was built on seven hills. We had believers far and near, from *Compton's Picture Encyclopedia* to *National Geographic Magazine*. In 1913, our "city of seven hills" made chapter 7 of

# Introduction

Edward Hungerford's *The Personality of American Cities*, where we were neatly tucked between Washington, D.C., as the "American Mecca," and Charleston, South Carolina, "where romance and courtesy do not forget."

The spirit of our urban myth hit its zenith in 1937, when City councilman John Hirschberg, also known as "Little Father Byrd," introduced an ordinance that would have made our seven hills law. In this ordinance, he named them as Church, Union, Shockoe, Gamble's, Navy, French Garden, and Council Chamber. But alas, our Little Father faced unexpected opposition from the nine-member council. Why, you ask? Because seven is not neatly divisible by nine, and each councilman wanted a hill for his constituency.

There were surely plenty to choose from, as hills abound in our fair City. The *News Leader* came up with 67 hills in 1952, among them Buck, Goat, Dead Man, and Poor House – all hills best left in the closet.

In defense of our erstwhile council, a hill by any other name may be a better hill. Take Church Hill, also known as Indian, Richmond, and Town Hill. Or Union Hill, which was formed by leveling and then reappointing Doen's and Stricker Hill.

In a twist of irony almost too sweet for history, our tallest hill actually has no name at all. It sits at a lonely 312 feet alongside the corner of Patterson and Three Chopt.

There is good reason to claim affinity with Rome, to celebrate our hills, and cherish our not-so-ordinary urban myths. There is even better reason to climb a few, to rise above the fray if only for a few moments, and align the contours of our sweetly crooked paths. After all, said the good poet Frost, "[Paradise] gives its glimpses only to those not in position to look too close."

# Introduction

But Richmond is more than a collection of hills. And with great respect to her champions of old, she is no Rome. She is her own place, different from any I know, with storylines that tantalize, evoke, and beg for an encore.

Richmond is baseball, home to both the first spit ball and bunt. She is beer in a can, the first to be sold in America. She is a giant, prehistoric fish, with scutes instead of scales, whiskers called barbles, and eyes of golden iris. She is a castle, a garden, a park, an old school for the first generation of freedmen and women, a prison turned university, the Fast Flying Virginian and the Silver Meteor, duelists and gangsters, streetcars and dip-to-dips, a sanatorium for noisy song birds, bluesmen in dappled purple tuxedos roaming the Bottom, and dyed-in-the-wool piano men banging out fifths and sevenths in the Ward's Happy Land. She is a place of impossible beauty, and squalor, and three-foot-tall heroes, their earnest little voices struggling to be heard in swept-away places on forgotten hills. She is a collection of smells that are woozy, drizzled, and textured, like raspberry jam on a warm country biscuit.

Walker Percy once reflected on the sorrows of the dying western world, amidst the chatter of neighborhood children and the smell of fresh cut grass. If this is sorrow, then Richmond is redemption. She is an old-time preacher at the pulpit, bellowing like a horn to a chorus of hallelujahs and amens, a scene made larger than life with the power of words intoned like music.

Richmond is a poem, a hymn, an anthem. We may have forgotten some of her lyrics. We surely have more to add. But let us sing what we know. And rejoice in what is good, learn from the rest, and pause to appreciate this fair little City, this tangle of life, noise, and energy heaped layer by layer onto the shadows of the past.

Richmond is my Muse. She has drawn me into her storylines. Some are printed here. But don't just read them. Take them with you. Go on, have a look.

# Getting Around

**F**ans of *Frommer's* beware! This book may very well take you past where the sidewalk ends, to haunts that no longer exist, moods that are as ethereal as lilac dust, and broken-down alleys that beg for the artist's eye, the

adventurer's spirit, and when all else fails, a casual disregard for reality. It is at this point, I think, at this precise point in the pulse of the City, that you will find the pilgrim feet and purple mountain majesty of Richmond.

The epicenter for this little adventure is the Bell Tower at Capitol Square, which can be found at the intersection of Franklin and 9th ☆. From there, you may follow our stories in any direction.

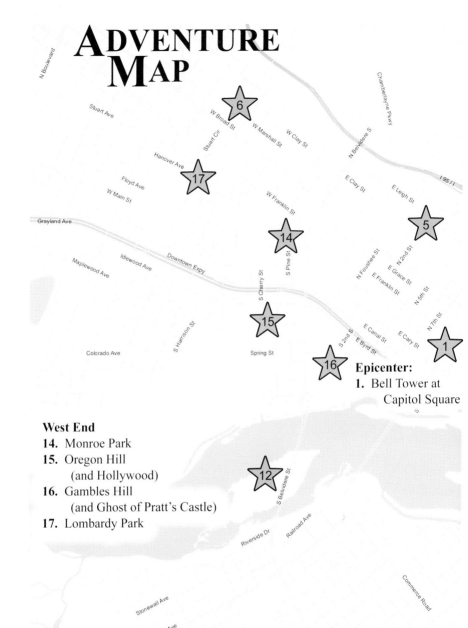

# ADVENTURE MAP

**Epicenter:**
1. Bell Tower at Capitol Square

**West End**
14. Monroe Park
15. Oregon Hill (and Hollywood)
16. Gambles Hill (and Ghost of Pratt's Castle)
17. Lombardy Park

**Southside**
12. Belle Isle (and James River)
13. Forest Hill Park

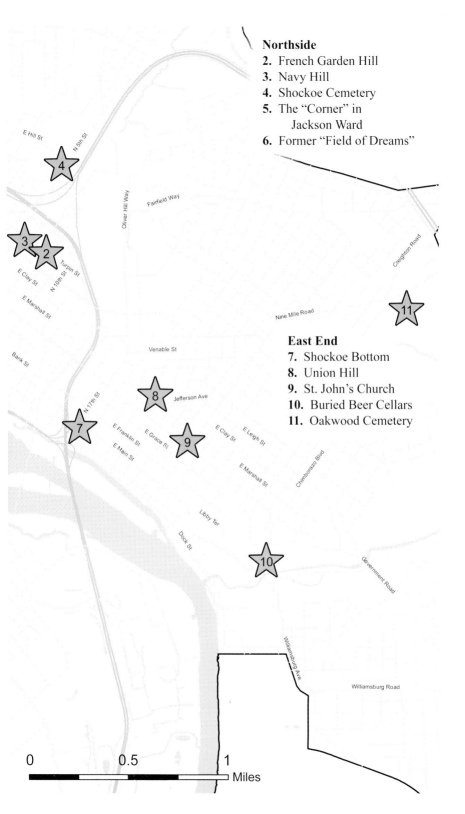

**Northside**
2. French Garden Hill
3. Navy Hill
4. Shockoe Cemetery
5. The "Corner" in Jackson Ward
6. Former "Field of Dreams"

**East End**
7. Shockoe Bottom
8. Union Hill
9. St. John's Church
10. Buried Beer Cellars
11. Oakwood Cemetery

0     0.5     1
Miles

**H**ead north on 9th to the dead end past Leigh and you will find the remnants of both French Garden Hill and the newly-razed Larrick Center ☆. Shuffle in a right-leaning square down Leigh to Jackson to what once was 6th and Duvall and you will find a little side-street sign that demarks Navy Hill ☆. Cut east on 5th above the highway and you will end up at a junction with East Hill, which is also the gate

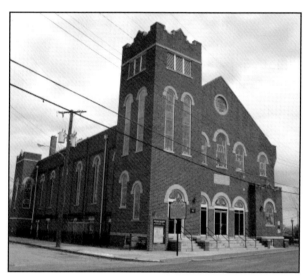

into Shockoe Cemetery ☆. Return on 5th to a string of rights on Jackson, Price, and Duvall and you will find yourself in a hard-scrabble patch of grass out of which rises the Sixth Mount Zion Church, long celebrated for its first pastor, John Jasper, and his improbably convincing sermon, "De Sun Do Move." Continue down Duvall to 1st, then lefts on Marshall and Leigh, and you will come to the Soul of the Corner, which is the hulking old Eggleston Hotel at the intersection of 2nd and Leigh ☆. Finish by heading due west on Clay to the junction with Lombardy, and you will find yourself in a grocery store parking lot that was once home to the first enclosed baseball stadium in the City, and now a soda pop and a cookie, which you surely deserve after navigating this first quadrant of old storylines ☆.

**H**ead south on 9th, cut east on Bank, right on 15th and then left on Main to find your way into Shockoe Bottom ★. Don't forget to pause at the Reconciliation Triangle on the corner of 15th, and the surface lot under the tracks on Main, both of which mark the past horrors of human bondage. Continue east on Main and you'll pass all manner of deserving landmarks – the old Main Street Train Station, the 17th Street Farmers Market, and the Poe Museum, to name a few. Cut left on 21st and right on Broad and you'll find yourself heading up the incline to Church Hill. Miss the turn and you'll hit Jefferson Park, which sits atop the fabled Union Hill ★. Make it and you'll soon see St. John's Church beckoning from the corner of Broad and 24th ★. Keep straight and you'll find the start of Libby Hill at 29th (veer a block south and you'll come to the Soldiers and Sailors Monument), then

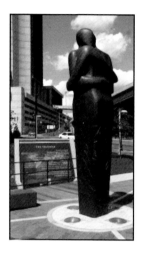

Chimborazo Hill at 32nd. The old beer cellars are buried under the round house at Grace and 34th (tucked within Chimborazo Park) ★. Blame either the folly of buried beer or the finality of the next destination for the thirst you may feel heading to Oakwood Cemetery, which is a stretch down 31st to the junction with Nine Mile Road ★. Don't let the new cemetery throw you. If you loop around to the back, over the bridge, and through the lowland woods, you'll come up and over a bluff that unveils the old section, with markers that stand like graying whale bones against the weight of the past. If you measure yourself up with the canons that edge the cemetery, you may find the line of light that once pitted McCarty against Mordecai in Richmond's most famous duel of the heart.

**H**ead south on 9th across the bridge and you will behold the majesties of the river, her tumble of noise and fishes and birds, her falls and her islands – among them, the one first known as Broad Rock for the immense granite outcropping that extended 100 feet in every direction without fault or fissure ✪. This is our "wet Central Park," our blue-way, our crowning jewel, and in the majesty of her murmurs you may enjoy many happy days... oblivious, as William Byrd II once wrote, even to the "notes of a scolding wife." Head right on Semmes and you will ramble on down to the connection with Forest Hill, and a'ways past you will come to the intersection of the old Boscobel at 41st Street ✪. The amusement rides are long gone, but cup your ears and you may still hear the rounding-organ-call of the old carousel.

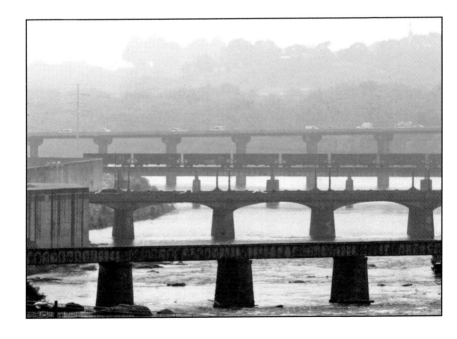

**B**acktrack west from 9th (with lawful regard for the one-way streets, of course) and you'll come at length to Monroe Park, the Grande Dame of Belvidere ⭐14. Head south on Belvidere and Oregon Hill will rise to the right ⭐15, and the old Pratt's Folly will haunt you to the left ⭐16. Venture in either direction and you will feel the tug of the gambler to wish for the moon. Circle back to our Grande Dame and then head further west to find the author swinging in the play-ground at the junction of Park and Lombardy ⭐17.

## Lost?

No worries, as a particularly precocious three-year-old is fond of saying from the pendulum of his own tot-swing, "not that front, the other front," by which he means, of course, the back. When he's older, like us, he may realize that he uncovered the central unifying theme of life – we never really go back, just varying degrees of forward.

Godspeed!

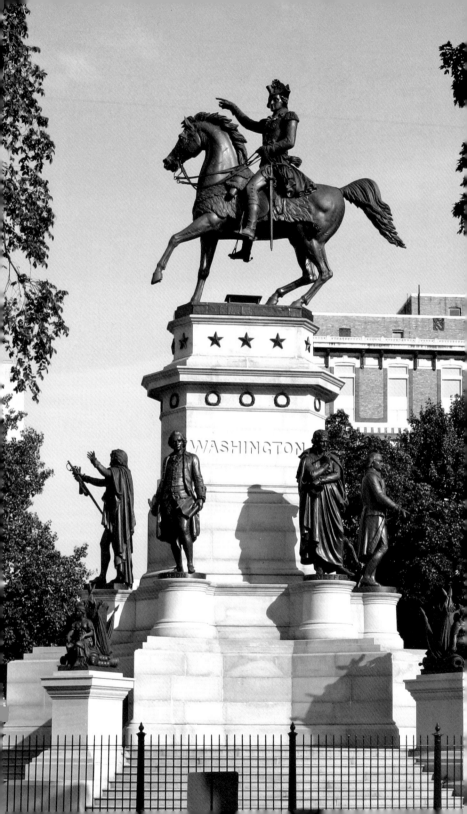

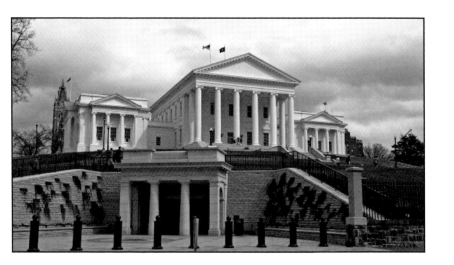

# It All Starts with Capitol Hill

**D**id you know that Richmond is home to the oldest parliament on the mainland of the Western Hemisphere; that Ike credited a fellow Richmonder for the impetus to become President of the United States; or that among the jumble of monuments distinguishing our fair City, Edgar Allan Poe has his own perch near the Bell Tower on Capitol Square?

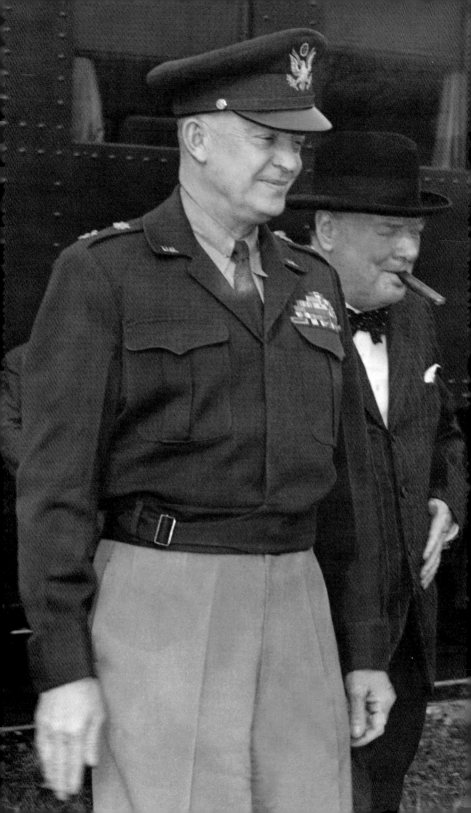

# Hello Ike!

I n Richmond, even our hills stand like monuments to the march of time. And though each of our fabled "seven hills" bears stories, perhaps none is as storied as Capitol Hill, home to the oldest parliament on the mainland of the Western Hemisphere. So how do I capture the essence of this great hill in three pages or less? Where do I go for a story that will keep you in your seat just a wee bit longer than usual? How about March 8, 1946?

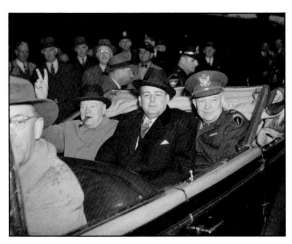

On this day, Richmond rolled out her guest carpet for Winston Churchill, the wartime prime minister of Great Britain, and Dwight D. Eisenhower, the supreme commander of the Allied Forces in Europe. They came to celebrate our little hill, and our occasionally querulous General Assembly, and our flag of Virtue vanquishing the tyrant. And we Rich-monders made the most of the occasion.

In spite of a beating rain, some 30,000 Richmonders stood by to watch the motorcade pass – from Boulevard to Monument, down Franklin to 5th, then Grace to Capitol Square. The newspaper reported that we stood as a "solid bank of human-ity," waving, and cheering, and throwing confetti.

At the Capitol, lines of cadets from John Marshall, Thomas Jefferson, and Benedictine High Schools stood at rigid attention for hours waiting for our distinguished guests to arrive. And when they did, Sir Winston, with his customary big black cigar, offered his famous "V" salute to these would-be soldiers of democracy.

Though Churchill was the main attraction, Eisenhower had his share of boisterous admirers who cheered, "Hello Ike!" from the drenched sidelines. Ike was not scheduled to speak, but perhaps because of the warmth of the welcome, he returned favor with brief reflections on Virginia, the birth home of his mother. And though he would not embrace politics for another six years, Ike later credited his visits to Richmond, and his discussions with our very own Douglas Southall Freeman, for the impetus to become President of the United States.

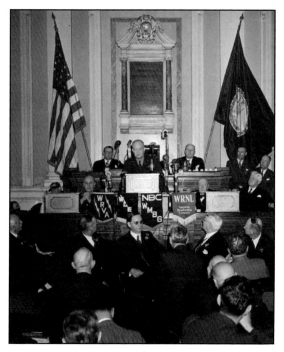

# Hello Ike!

These were auspicious times for Richmond, and progress danced in the air like a butterfly. Marvel bread sold for 12 cents a loaf; Mavis cola for 30 cents a 12-pack. You probably don't want to know what gas cost, but even then, there were some whimsical alternatives to the motor car. Consider Silver Rocket all-aluminum roller skates, which sold for just $8.95 a pair. On the day of the visit, "The Outlaw" was playing at the Loew's Movie Palace, with Eddie Weaver at the console of the theatre's Mighty Wurlitzer. And Thalhimer's had the grace to shutter its store so that its employees could participate in the lofty occasion.

It is hard to find truth in the ravages of war, but it is important to celebrate Virtue vanquishing the tyrant and the principles of freedom that follow. Where better to do it than Richmond's own Capitol Hill, that mighty crest of democracy ringed ever and always by a solid bank of humanity.

*Note: On March 8, 1946, Frank Dementi, working out of his Colonial Williamsburg Studio, recorded the historic visit of Winston Churchill and General Dwight Eisenhower to Richmond and Williamsburg, Virginia. He followed their journey from their arrival at the train station in Richmond, through their joint appearances at the Virginia General Assembly, and on to Colonial Williamsburg, where he was afforded the unique opportunity to photograph Churchill and Eisenhower at the Raleigh Tavern, with no other photographers present. Can you imagine how you would feel being singled out of a crowd of 200 newsmen to photograph two of the world's most admired post-WW II figures? At first, Frank was, in his own words, "scared to death," and he wouldn't even acknowledge his summons to enter the Raleigh Tavern. At length, he did, and the rest is history. We are pleased to permit some of his pictures from the trip to accompany this essay.*

*Frank's sons, Brian Dementi and Wayne Dementi*

IT SEEMED LIKE REACHING FOR THE MOO

BARBARA JOHN

# Pillars, Symbols, and Other Lessons

We have been erecting monuments since the dawn of recorded time. Through colossal heads and earthen mounds, pyramids and stone circles, fountains and pillars, we have sought to memorialize our triumphs and sacrifices. Surely our monuments are only a part of our collective expression, but unlike our written history, they stand stubbornly in the face of change. They may tarnish and crumble, or topple from their mounts, but they persist as symbols of what we were, wanted to be, or hoped one day to become.

Richmond is home to some of the most incongruous monuments in the world. Within the storied circles of Monument Avenue stand larger-than-life memorials to civil strife and civic pride, to conquerors and the conquered, to the most famous and infamous of our native sons. But Richmond's monuments neither begin nor end on that grand avenue. Tucked into our many neighborhoods and parks, and our public buildings and public squares, stand memorials to all of the world's wars, five of the country's presidents, Christopher Columbus, Edgar Allan Poe, Bill "Bojangles" Robinson, the great flood of 1771, soldiers, sailors, and allegories of providence, temperance, liberty, and redemption.

Our Capitol Square is a veritable lesson book of statuary. Some of her monuments are giant and pitched forever in

action, like Washington atop his charger in the circle; others are so delicate as to be nearly flesh and bone, like Washington in the rotunda, chiseled by the famed French artist Jean-Antoine Houdon; and still others are elusive, like our prodigal son Poe, who haunts the grounds of the Capitol with pen and stories in hand.

With our statuary comes great lore – some fact, some legend. Among the best is the story behind the mass memorial to Confederate soldiers in Hollywood Cemetery, an imposing pyramid of James River granite set without a morsel of mortar. Legend has it that the pyramid was so tall that only

an imprisoned sailor was daring enough to set the capstone in 1869, in return for which he earned his freedom.

Our monuments cannot be hung like paintings or shelved like books. They must be received where they have been planted, amidst our homes and daily passages. Just down the street from my home is a little triangular park edged with shrub trees and brambles. Up through the

greenery rises a statue of a soldier carrying a musket. The inscription reads, at least in part:

*Erected to the imperishable memory of the valiant fallen who through seven American wars endured hardship with patience, met defeat with constant courage, did not vaunt their victories, and steadfastly kept the faith.*

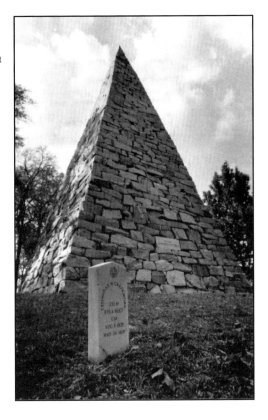

Richmond is a City sprung from the ashes. She is a City on the move. But if we move too quickly, we may forget the lessons of the past. We are surrounded by them – stone and bronze memorials to heroism, pride, and sacrifice. They may be easy to ignore, but they are a part of our living history. And although they may be imperfect to some and incomplete to others, they still bear the mark of what we were, wanted to be, or hoped one day to become.

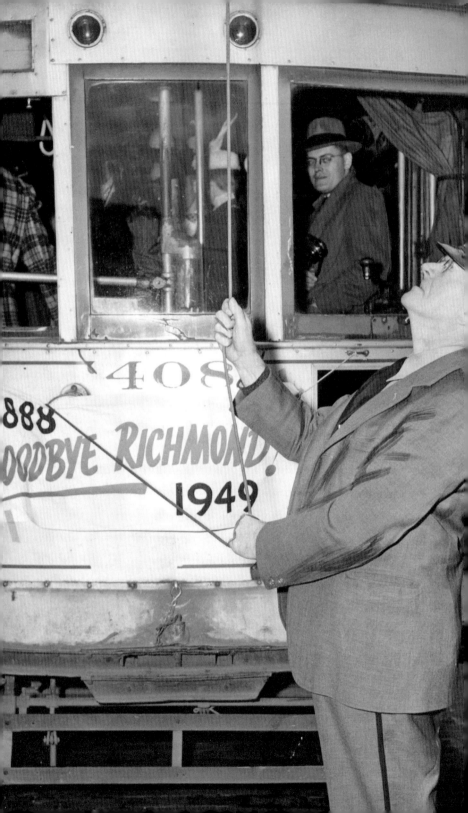

# Northside

Our northside hills are all but leveled by time and progress, but their stories remain to be told. Just think, French refugees once tended pleasure gardens at the north end of 9th Street, atop a hill named "French Garden" in their honor; pioneering educators established the first schools for the post-Civil War freedom generation around a little patch of paradise known as Navy Hill; and the family of Revolutionary War hero Paul Revere provided the gravestone for our City's most famous (or infamous) spy. Down but not forgotten at the base of these hills are the storylines of died-in-the-wool piano men and our very own field of dreams.

# French Gardens

In Richmond, every hill tells a story, but sometimes you have to dig around a little first. You may find an old stone foundation, or an arrowhead, or a flint, or a cannonball, or the sinewy seeds of an old lemon, out of which, of course, you must remember to make lemonade.

You may also find a riddle, like this one: What perch in Richmond connects an island, a wigmaker, and a garden, or should I say instead, revolution and paradise?

The island is Hispaniola in the West Indies, colonized as San Domingo by the Spanish and Saint Domingue by the French. An island rich in history, sugar, coffee, and marauding buccaneers.

The wigmaker is Didier Colin, a Frenchman by birth, who came to Richmond in 1793 and made his home atop the hill that once stood at the north end of 9th Street.

And the garden is a "remote suburb" of our fair City, in which there grew a tangle of grape vines, fruit trees, and flowers, and to which neighbors flocked for respite from the noise of the day.

Amazingly, these fragments connect. In August 1791, the slaves of Saint Domingue staged a spirited and bloody insurrection. Among the French colonists to escape was Didier Colin, who made his way with other refugees to Richmond. They encamped on a hill above Shockoe Valley considered at the time to be a "remote suburb" but truly now just a few blocks from our City center. And there, perhaps in tribute to the kindness they first received as indigent refugees, these Frenchmen planted gardens and served fruits and lemonade for the peace and amusement of their neighbors. They

became so beloved for their generosity that their camp
became known as French Garden Hill.

So what of revolution? Well, word of the Saint Domingue
insurrection followed the refugees to Richmond. By 1800,
this insurrection had become both a model and a motto for
our first slave rebellion. And while the brave-hearted rebel,
Gabriel Prosser, lost his life for this borrowed battle cry, it
echoed around the world, leading, almost inevitably, to the
Civil War and the burning of Richmond.

In a twist of irony almost beyond belief, the hill of the Saint
Domingue refugees, the wigmaker Didier Colin, and the
gardens, was leveled and rebuilt as the Virginia Civil War
Centennial Center in 1961.

So if you go looking for French Garden Hill, you will find nothing but the odd dome-shaped building now known as the Larrick Center. But if you dig, you will find revolution and paradise, and perhaps one day, some lemonade.

Note: Sadly, the Larrick Center is also now gone, its roof beams leveled like those in the "tall, thin house" of the old French refugees.

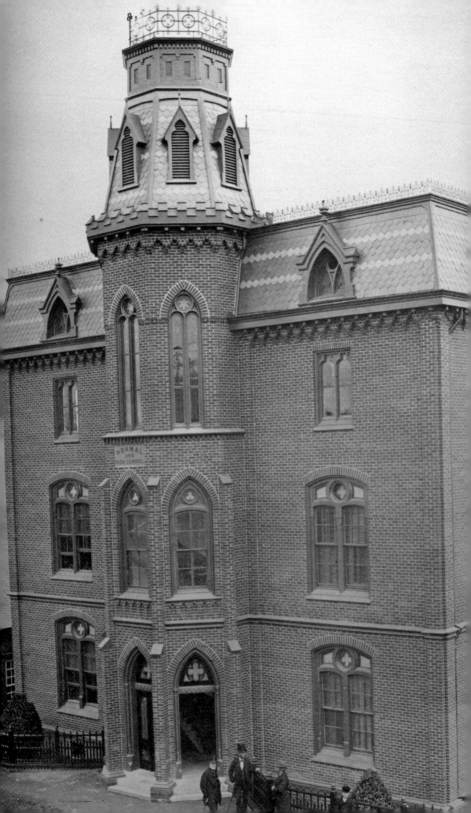

# The Famed Schools of Navy Hill

When we are young, we are asked to learn. And as we grow older, we are asked to teach. And though we spend lifetimes rolling and tumbling over what we thought we knew, we never forget the first impossible moment of inspiration sparked *by* or *as* an educator.

So what did you learn today? What, me first?

In this City of dreams, shaded black and white by the charred pencils of our past, there once was a little patch of paradise just north of Leigh Street, separated

from Jackson Ward by a "deep and gloomy" ravine. In the early 1800s, ambitious land speculators proposed to develop lots on the ridge above the ravine, along with a pillar to commemorate the valiant naval heroes of the War of 1812. Sadly, this pillar was never built, and the lots idled vacant for years, but the name Navy Hill stuck, at least until it was plowed under to make way for the interstate highway system in the 1960s.

If you go looking for Navy Hill now, you'll find a dead-end street and a parking garage. But what you should find is a pillar to Chaplain Ralza Morse Manly engraved with poetry.

Manly was a Vermonter who served in the First Colored Cavalry during the Civil War, and then emigrated to Richmond to become the first superintendent of black schools in Virginia under the Freedman's Bureau. Manly believed that the only true form of "Freedman's Aid" was education,

and he devoted his life to creating schools that might "elevate the aspirations of the colored youth of the city."

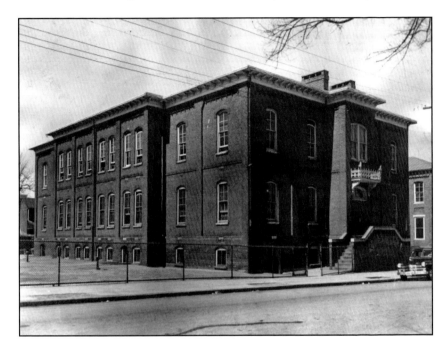

Manly wrote and lectured with great passion. Among his favorite subjects was the importance of the educator in a young person's life.

> *It is true that we cannot trace any particular grace or ugliness in the man, clearly and separately back through the course of years to its fountainhead, no more than we can trace the particular drop of water that glitters upon a spine of grass, up through its path in the sky, down to the ocean and thence to its particular fountain underground, but we know equally as a general truth where both had their source. The common school teacher then not only impresses himself upon his pupils by an unchangeable law, but in every day does a work which neither man nor angel nor God himself can undo...*

# The Famed Schools of Navy Hill

*Whatever character can be desired for the child, when he shall become a man, either by the dictates of enlightened reason, the fervor of parental love or the necessities and wants of a fallen world, precisely such in kind, if possible should that school teacher be. (Manly lecture from January 10, 1851)*

In post-war Richmond, Manly surely found himself surrounded by the remnants of a fallen world. But instead of dismay, he saw opportunity. In 1867, Manly established our first "colored normal school," an imposing two-story brick building at 12th and Leigh equipped with a bell tower, a science laboratory, and a library of more than 500 books. Manly served as principal of this school for 18 years, but his tenure was not free from worry or discomfort. In fact, for some of these 18 years, Manly reportedly lived in the basement due to "the stress of the times and the unpopularity of the cause." Undeterred, Manly also helped to establish an elementary school at 6th and Duvall. This was one of only four schools for black children in the City and the only one with both black educators and students.

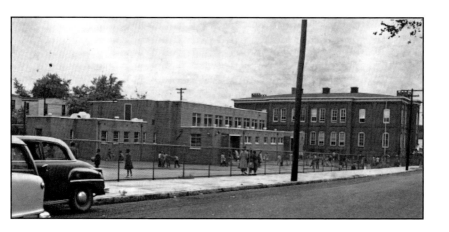

# The Famed Schools of Navy Hill

Manly's schools up on Navy Hill were considered to be some of the finest in the land. In them, students were exposed to foreign languages, higher math, geology, cartography, and history. And while the sight of Manly's students toting around stacks of textbooks surely raised some suspicious eyes in old Richmond, eventually this suspicion turned to pride. In fact, by 1873, even the least progressive of the City's newspapers was swayed to report on the remarkable educational quality of the schools.

Many of Richmond's most famous black daughters and sons matriculated through Manly's schools, including Maggie Walker, the first woman in the United States to establish a bank, and John Mitchell, Jr., the crusading editor of the *Richmond Planet*, one of the oldest and most prominent of the nation's black newspapers. And to read their remembrances is to mark with indelible ink the inspiration conjured by their teachers.

> [They] guided our childish feet, trained our restless hands, and created within our youthful souls an unquenchable search for knowledge, an undying ambition to be something, and to do something, to lift ourselves and our people from the degradation of innocence and ignorance and poverty to competence, culture and respectability. (Maggie Walker on her experiences at the Navy Hill School with educators like O.M. Steward, who also founded the City's first black newspaper)

Sadly, nothing lasts forever, not dragons, nor little boys and girls, nor even the schools in which they experienced the first impossible sparks of inspiration. Manly's normal school was condemned in 1908. And its formative sister, the Navy Hill School, was demolished to make way for Interstate 95 in

1966. Ironically, the only remnant, a detached gymnasium, became home to our first Children's Museum in 1977.

So as you hurtle down the highway past a broken hill that marks the end of an old, nearly forgotten neighborhood, as you reflect on the progress and healing that shades our fair City, pray pause to remember that little patch of paradise known as Navy Hill and the feats of human conviction – both learning and teaching – that were neither black nor white, but like the name of the school, "colored normal."

We missed our first chance to erect a pillar, but we should not miss our second.

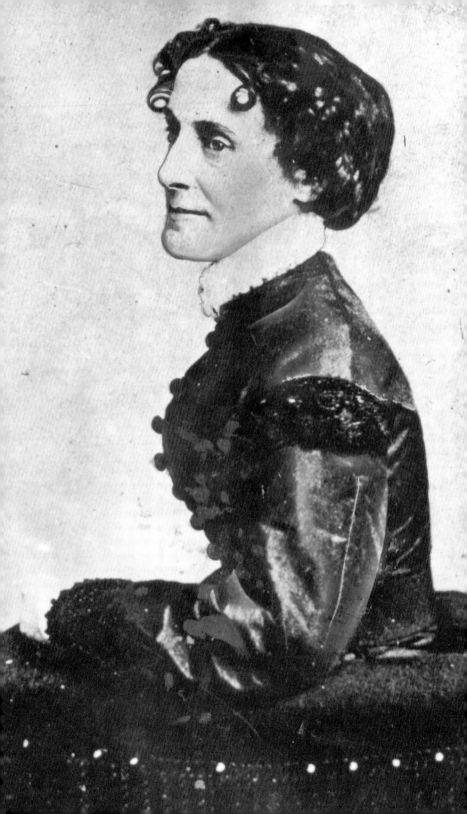

# Crazy Bet

The hills of our fair City sometimes converge, their stories piled together like driftwood on the banks of the James. And though we take pains to sort and separate them, every now and again, we need to tell the stories exactly as they lie, in a jumbled heap of fame and infamy. How else might we spin a tale that connects two hills, two presidents, a dimwit, a poet, a Revolutionary War patriot, a Civil War spy, and the most celebrated banker in the country?

This tale begins on Church Hill, the oldest neighborhood in our little metropolis, her streets laid by Colonel William Byrd, founder of the City, decked by the steeple under which Patrick Henry made his famous "liberty or death" speech, and dotted by mansions built by old Mr. Adams and his three sons.

One of these mansions passed from Adams to Van Lew, who prospered in hardware and gave unto us daughter Elizabeth, oft remembered as a crazy old maid but surely once a not-so-crazy young maiden. Elizabeth enjoyed a childhood of grace on Grace, and there are even accounts of Poe reciting poetry in her parlor. As she grew, Elizabeth became an outspoken critic of slavery. When her father passed, Elizabeth used her inheritance to liberate all of her family's servants, among them the parents of Maggie Walker, who went on to worldwide acclaim as president of the St. Luke Penny Savings Bank.

When war broke, Elizabeth turned spy. She donned a battered bonnet, mumbled to herself, bent her head, and feigned the dimwit so successfully that she became known as Crazy Bet, a seemingly harmless eccentric who enjoyed free passage to the prisons of Libby, Castle Thunder, and Belle Isle. There she dispensed food, books, and medicine while secretly

logging the size and location of Confederate forces to pass along to the Union army. She even managed to infiltrate the Confederate White House through an accomplice who played servant to President Jefferson Davis. Among the connections born from her duplicity, Elizabeth befriended a young Union prisoner from Massachusetts, who was the grandson of Revolutionary War hero Paul Revere, and General-then-President Grant, who called Elizabeth the Union's most valuable informant in Richmond.

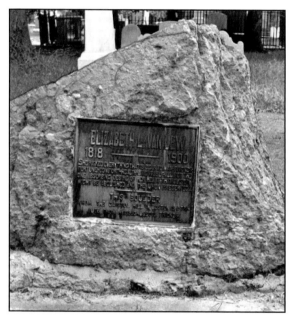

In fallen, post-war Richmond, Elizabeth suffered the bitter enmity of her neighbors, and in her final years, a life of loneliness and abject poverty surrounded by 40 cats in the crumbling old family home. Elizabeth died in 1900, and was laid to rest up on Shockoe Hill under a rock marked as follows: "She risked everything that is dear to man – friends, fortune, comfort, health, life itself, all for the one absorbing desire of her heart – that slavery might be abolished and the union preserved." Guess who paid for and placed this rock? You guessed right, Elizabeth's Massachusetts friends.

These hills and stories are now just driftwood, sorted and separated and painstakingly preserved in the annals of Richmond's history. But if we take a few moments to find Elizabeth's rock, we may yet feel a force of collision that reminds us to be bold in our compassion for the revolution- aries, poets, and spies of our past.

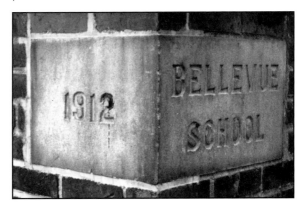

Note: The Adams-Van Lew Mansion was leveled and replaced with a school in 1912.

# Soul of the Corner

he Corner is not what it once was, but it abides. Beneath weather-beaten boards and tattered playbills, there remains the hint of swing, the sweet wail of bop, and the shuffling boogie-woogie vibe of a last set played too long ago.

In the years leading up to World War II, Jackson Ward was Richmond's jazz mecca. It teemed with dance halls, ballrooms, nip joints, and clubs like Waltz Dream, Happy Land, Shorties, Heat Wave, and the Top Hat. It was home to the Hippodrome Theatre, the Globe, the Rayo, the Roseland Ballroom, and Neverett's Place in the Eggleston Hotel.

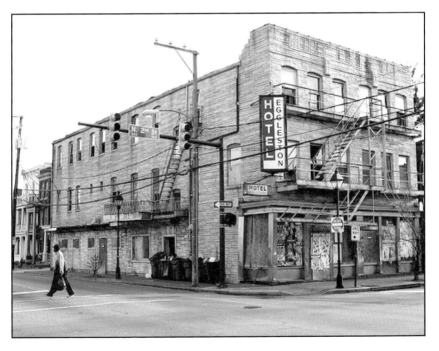

Jackson Ward hosted the greatest jazz acts of the day – Louis Armstrong, Benny Goodman, Lena Horne, Cab Calloway,

Nat King Cole, Billie Holliday, Count Basie, and Ella
Fitzgerald. And it grew its share of jazz greats too.
Johnson's Happy Pals, a 10-piece swing orchestra from
Jackson Ward, beat Fletcher Henderson and Duke Ellington
in a band contest in New York City in 1929. "Fats" Tyree,
one of the Ward's mellow horns, ended up traveling the
world with the Louis Armstrong Orchestra.

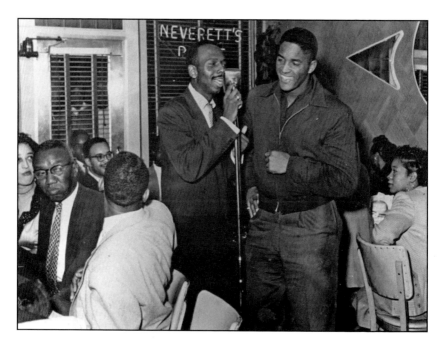

Jackson Ward was surely a romping place in its heyday, with
dyed-in-the-wool piano men banging out blue notes with
their elbows and the notorious Purple Gang patrolling the
Corner for a piece of the action. Visiting orchestras would
spend a day or two playing the staid, society ballrooms on
the sunny side of Broad, and then uncork for special encores
before the reveling crowds of Jackson Ward.

Richmond's jazz scene is more diffuse these days, but no less prolific. In any given week, the fuzzy bomp of jazz headlines at least 30 events in our fair City, from smoky gin joints to more austere university festivals, from street corner improvs to the smooth groove of WCVE Public Radio's own Peter Solomon.

The Ward is a different place now. Drive through it on a rainy Sunday morning and you will feel pride for its past, hope for its future, and melancholy for the hallowed, wrecked hulls of its many jazz landmarks.

If Preservation Hall in New Orleans can survive a tempest, then surely we can reprise the sublime rhythms, textures, and moods of our own jazz roots. The Soul of the Corner begs for an encore.

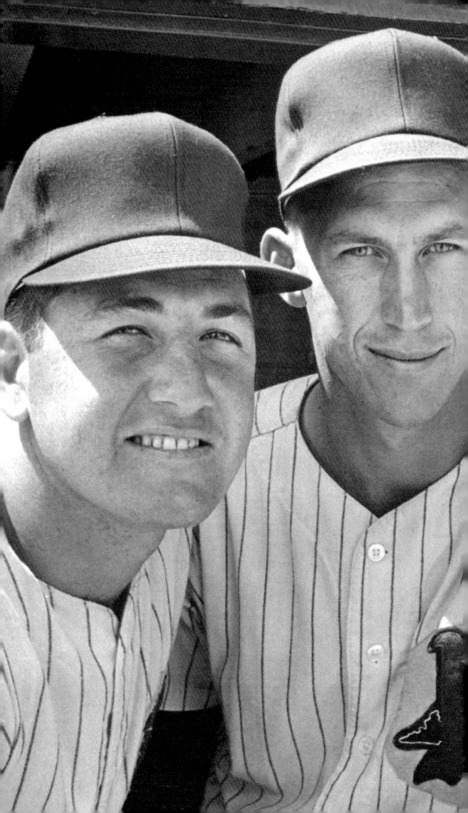

# Field of Dreams

**B**aseball is a state of mind. It is childhood suspended in the slant of the afternoon sun, the smell of peanuts and suds and ballpark franks, the rush of a fast ball, and the melancholy or glee that follows the last out of the day.

Baseball is not the best team, or the strongest bat, or the fastest pitcher, or even the glitziest stadium. No, baseball is a story passed down from father to child about the improbable come-back, or the vainglorious defeat, or that time when Barefoot Billy Butler fielded a blooper

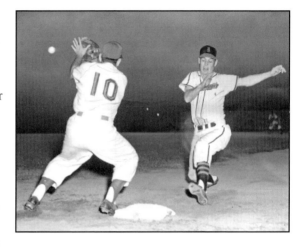

from Charlie Ferguson and threw it home so hard as to knock a plank off the infield fence. Remember that time?

Baseball in Richmond is a shadow of the City itself, fitful but resurgent, indomitable, and old. So old – that like many other things in our fair City – we sometimes forget to mark the spot. If you try to mark it now, you will find a parking lot. But what you should find is a statue of Henry C. Boschen littered with roses.

Boschen owned a shoe factory back in the 1870s. At the ripe old age of 33, he was advised by his doctor to become more active, so he traded his shoemaker's bib for a bat and ball and went into the field to play. He enjoyed it so much

that he organized a team out of his employees and built them a ballpark in Sheep Hill, replete with a covered grandstand and special seating for the ladies.

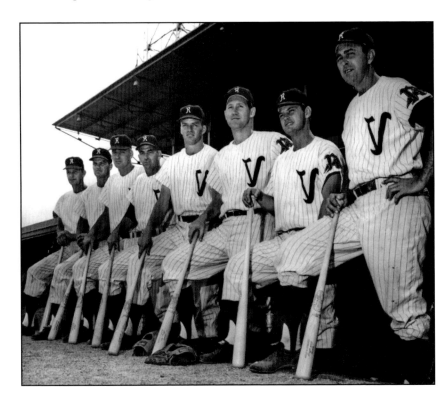

Boschen's team, the Virginians, went on to great fame. And Boschen was more than just owner or president. Among his many credits as a player and a scout, he was rumored to be the first to throw a spit ball, the first to lay down a bunt (known at the time as a "Boschen"), and the first to recruit Charley Ferguson to the game – the same Charley Ferguson, that is, who went on to a distinguished major league career with the Philadelphia Athletics.

Even back in the day, professional baseball had its share of critics, who believed the game to be "very little less injurious than gambling," leading idle boys to lives of dissipation and vice. And Boschen must have sensed some truth in this criticism, because he refused to participate in the incorporation of his team in 1883. Sadly, most of Boschen's star players were lured away by the promises of corporate money, and Boschen was left teamless. Down but not out, Boschen challenged his old team to one last game. His replacements were roundly thumped, but amidst the looming clouds of defeat, Barefoot Billy Butler hurled the ball that knocked the plank off the infield fence. And in the high tradition of baseball lore, that was even better than roses.

Boschen is long gone. Sheep Hill no longer exists. And the stadium is now a parking lot at the intersection of Clay and Lombardy. But remember, baseball is a state of mind. Close your eyes, and mark the spot, and maybe, just maybe, you'll be recalled to that old field of dreams.

I n a little church just east of City center, on March 23, 1775, Patrick Henry rose and offered a new nation her soul. "Is life so dear," he asked, "or peace so sweet, as to be pur-

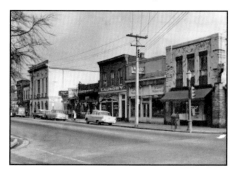

chased at the price of chains and slavery? Forbid it, almighty God! I know not what course others may take; but as for me, give me liberty or give me death!" Still other storylines beg for an encore along the crooked paths through Shockoe Bottom up to Church, Libby, and Chimborazo Hills and beyond. They tell of hope, redemption, determination; the power of poetry; the *code duello*; and desperados. Oh, yes, and beer too!

# C-Jam Bottom Blues

Muddy water rollin' down,
Down and through my city.
Scoured through, this nonesuch place,
My place of toil and pity.

And up again, she rises true,
That mellow yellow sun.
And lights my city fair and bright,
To guide us one by one.

Through the trestles, lock and chain,
The broken and the broke.
To hallowed ground, our tempest tossed,
Grace at last she spoke.

Shockoe Bottom has weathered 400 years of hope, tears, and redemption. Walk it now and you will see the promise of a new day – new restaurants, shops, and old warehouses rehabilitated into homes. It is a place of spectacular revival, a place marked at every turn by some restored remnant of the past.

But to understand Shockoe Bottom, you cannot simply look in or pass by. You need to pause, ponder, and look out. You need to stand in the shoes of Captain John Smith and proclaim "no place so strong, pleasant, or delightful." In the shoes of the masses of men, women, and children penned and sold like chattel from one misery to another. In the shoes of the masses of soldiers interned at Libby Prison, where "hope was all that sustained many." And in the shoes of our prodigal son, Edgar Allan Poe, who wandered the streets of the

Bottom from his boarding house on Bank Street to his first post at the *Southern Literary Messenger*, musing over words that would become his only novel, a play, and untold fodder for his prolific arc of poems.

The Bottom has accreted an incongruous collection of stories – stories to rend and make you weep. It is a place of physical and emotional storm, a place beaten and scoured and yet resurgent. Even Devil's Half Acre – the site of the notorious Lumpkin's Slave Jail – was miraculously transformed after the Civil War into a school for freed slaves, a school that ultimately became our celebrated Virginia Union University – from the pens of suffering to the pens of knowledge.

Shockoe Bottom is hallowed ground. It is a place for bluesmen in dappled purple tuxedos. A place to croon over the past and find grace in the broken refrain.

# Choo Choo

Trains have been rumbling through Richmond for 175 years. They are a part of our legacy, landscape, and lexicon. Like a blues song of deprivation mixed with a children's story of determination, the mark of trains on our City is as tortured and redemptive as our past.

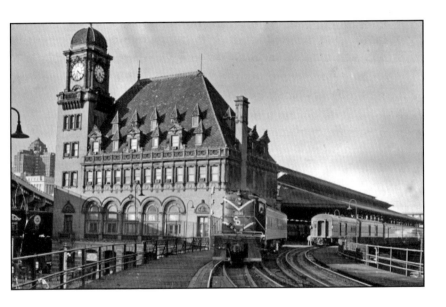

The first trains in Richmond were powered by gravity and mules. They were followed by steam engines that connected short-track railroads from the mountains to the sea. Control of these railroads augured the outcome of the Civil War, including the evacuation of Richmond on April 2, 1865, and Lee's surrender in Appomattox a week later.

The golden age of trains in Richmond emerged following Reconstruction. In 1901, the first of Richmond's grand "union" stations was built on the site of the old Saint Charles Hotel in Shockoe Bottom. With Pompeiian brick walls, a terra cotta roof, and a six-story clock tower, Main Street

Station has served as an unmistakable symbol of the City for over a century. The world's only triple-train crossing rises near the roof beams of Bottom's Up Pizza just two blocks away.

In the early days of parlor cars and velvet, Richmond was a destination for some of the most famous passenger trains in railroad history, including the Fast Flying Virginian, the Silver Meteor, and the Orange Blossom Special. The City also served as a crossroads for prodigious coal drags from west to east, tobacco runs from south to north, and other commerce of every shape and flavor. In those days, the caboose was a "crummy," the locomotive a "jack," the train cook a "lizard scorcher," and the train engineer a "pig mauler." Empires were made, brokered, and broken on the hot iron of the rails.

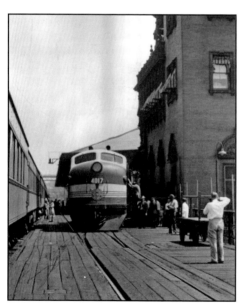

Nowadays, most of the old railroads operate under the banner of CSX, Norfolk Southern, or Amtrak, and the glorious old names and places have ceded to more austere terminals and codes. But their glittering lore still tugs at the souls of bluesmen and the imaginations of children. And their tracks still blaze a path between Richmond's mule drawn past and its high speed future.

# Choo Choo

I can feel that ol' train
a'rumbling down the track,
Clickety clack, clickety clack,
Dragging coal cars to Norfolk
and running empty ones back.

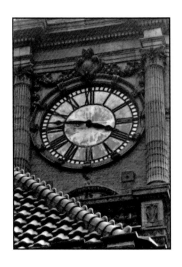

I can hear that ol' train
coming in this mean dark night,
Choo choo, hiss hiss, hi,
Hollering down the line
with its iron whistle cry.

And I can see that ol' train
in the shadows of the day,
Smoking and bellowing as if to say,
A new sun's a'rising,
and I'm headed your way.

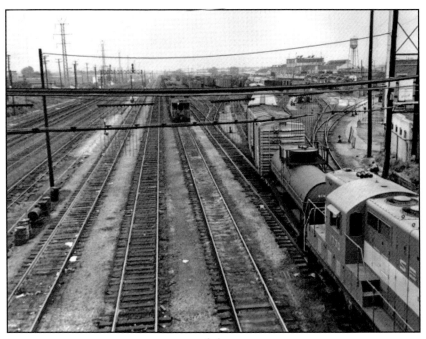

# Liberty or Death

The hill abides. Her little church abides. And inside the chancel, even her old Adam Stein organ abides. But when the stops wheeze open, and the ranks rumble and spout the opening bars of Bach's *Prelude and Fugue in A Minor*, there is a trembling, feet-tingling, hair-raising, heart-pulsing sense of awakening, of energy in motion, like water bursting through the cracks of a dam.

And if you pause to listen, to follow along as the organ growls in her deep-boweled baritone those bass notes so far below the clef as to emerge nearly under your feet; if you dare to lend your ear, you may hear the clank and crash or even the sweet melody of revolution. Not revolution in the ordinary sense, of freedman against tyrant, but organic revolution, like the bursting of an old thorny-stalked rose into a patch of weeds, or the flowering of a little purple nothing in the crumbling mortar of an old brick footpath.

Why not? The hill is littered with the pits and pocks of revolution. Just outside the churchyard – St. John's Church, that is – there is a marker to that dastardly Revolutionary War turncoat, Benedict Arnold, who invaded our City, took the hill, and torched our storehouses in 1781.

And around back, just past the bowed walls of the grave-yard, there is a marker to the lev-eled home of that oft-maligned Civil War spy, Elizabeth "Crazy Bet" Van Lew, who stashed  escaped slaves, prisoners, and her own horse in her secret second-floor study to protect them from capture. A proud but vilified southerner, Crazy Bet maintained the age-old revolutionary tradition of opposition to human bondage.

 Within the church-yard itself, amidst gravestones that tip and topple like graying whale bones on a beach, there is the headstone of that curious French-man, Didier Colin, who fled the Saint Domingue insur-rection of 1791, encamped here, and earned immortality with the hill named in honor of his pleasure gardens. Imagine fleeing revolution from half a world away only to come to rest, at last, at the doorstep of our most prized living memorial to revolution.

Ah yes, revolution. Inside the church, Patrick Henry once rose and offered a new nation her soul. "Is life so dear,"

he asked, "or peace so sweet, as to be purchased at the price of chains and slavery? Forbid it, Almighty God! I know not what course others may take; but as for me, give me liberty or give me death!"

The yard of St. John's Church is home to some 1,300 graves, but only 400 or so are still marked, and of those, a substantial number are illegible, their inscriptions washed away by time and a curious effect known as the "sugaring" of stone.

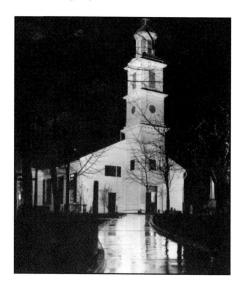

Oh, to think of the stories lost in the yard, of revolutionaries born or buried there, of the quiet seeds of discontent that have crept up with the old thorny-stalked roses in search of freedom, and liberty, and justice for all.

A school now stands in the place of Crazy Bet's home; a park in the place of Arnold's raid. And though the yard is quiet, the old pipe organ still rumbles from the chancel, and Henry's beloved oration is repeated weekly before crowds reverent and hushed, their heads strained forward, their faces pale, and their eyes wet, just like the gathered crowd 233 years ago.

God bless America, the republic for which she stands, and the revolutionaries who made her so. May we never forget to listen for their sweet melody.

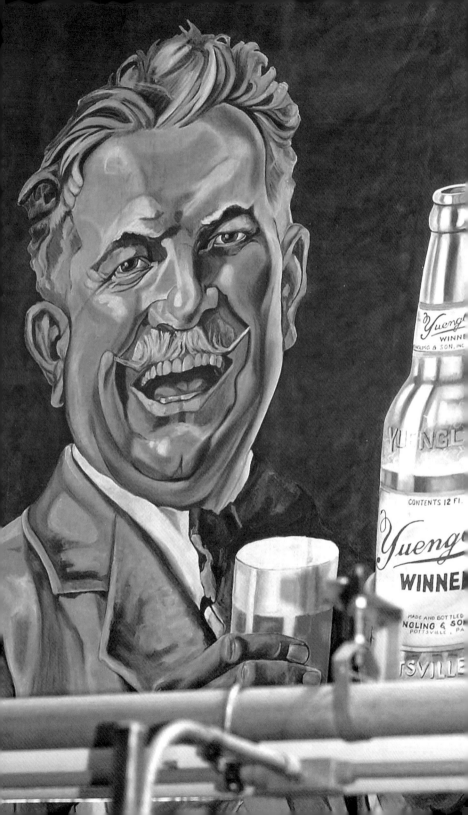

# All for Me Grog

I n Richmond, what lies under the hill is as captivating as what stands above. Imagine all the stories stowed in the basement. Imagine all the yarns wrapped like ribbon around the fiddles and pens of our bygone days.

Take the old Church Hill neighborhood, for one. Buried 30 feet below the old round house on Chimborazo is a nearly forgotten beer cellar, vaulted and brick-lined and massive enough to be designated as an air raid shelter at the beginning of World War II.

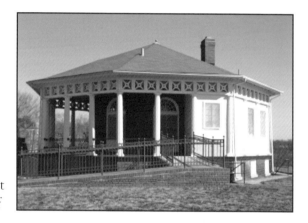

The cellar dates back to 1866, maybe earlier. According to a 19th-century City business directory, Mr. Frommel was the resident brewer and bottler. Others followed him in a string of ventures that failed not for lack of inspiration or recipe, but for ice, which had to be imported by boat from Maine.

In spite of this obstacle, Richmond was long considered a good beer town. With props to our many German immigrants, we brewed ales, porters, stouts, and lagers of all types – "nourishing beverages supplying all the essentials for the sustenance of the body, renewing health, and giving vigor to the weak."

We apparently drank our share too. When Charles Dickens passed through Richmond in 1842, he observed that we lived in a "thirsty" climate, and he was delighted by the music and merriment that filled our bars at all times of day and night. We dare not call this good cheer accidental. Around the time of Dickens' visit, our City boasted 112 saloons, 85 lawyers, 63 confectioners, 29 barbers, 12 booksellers, 3 brewers, 24 dealers of fancy goods, and surely somewhere, a partridge in a pear tree.

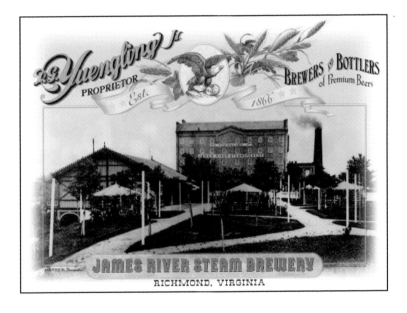

Richmond may not be a classic beer town like Milwaukee or St. Louis, but we have had our share of fame. In 1866, the nation's oldest continuous brewery, Yuengling, opened a second home here, operating as the James River Steam Brewery just down the hill from our fabled Chimborazo cellar.

Even during Prohibition, which began two years early in Richmond, we dabbled in "near-spirits," like the short-lived Pablo Temperance Drink. And when the taps started running again in the 1930s, Richmond was the first market in the country for "beer in a can." "Imagine," the ad read in the *News Leader* on January 24, 1935:

> *Imagine buying ale or beer for your home without paying a bottle deposit, without the trouble and effort of making bottle returns! Imagine being able to get twice as much in the same space in your ice-box. These are the modern conveniences made possible by the astounding keglined can.*

So beer is probably not the hallmark of our City. And old beer cellars may not be on every whistle-stop tour. But merriment is worth preserving, even when it lies 30 feet under the hill. Said the poet Tennyson, "I will drink life to the lees." Replied Homer Simpson, "Mmmmm, beer."

# Mount Chimborazo

Richmond is a song with lyrics lost and found and lost again. She is a quality of noise, a tremble of falling water, a pulse of crumbling brick. She is an exultation, not quite what she seems, but more, always more, like a Muse in the ashes of what was or could have been.

And though we have studied her, poking and prodding at the marks of her past; though we have recorded what seems like every grain of her fame and infamy; still there lingers the sweet uneven pulse of the unknown.

Consider the hill that crests above our City, the one that tops the bend in our river, the one we call Chimborazo. The name is neither native nor colonial. It comes instead from the improbably distant Andes of Ecuador, from the inac-

tive volcano that towers 20,577 feet above sea level and that reaches closer to the moon than any other mountain on earth.

Our little hill, some 200 feet above the high water mark of the James, surely wanes by comparison. So why, pray why, did we borrow the name of a giant? Mysteriously, no one knows.

When Benedict Arnold torched our storehouses in 1781, the hill bore no name at all. But by 1856, Chimborazo Hill was part of the accepted lexicon of our map-makers and historians. And, of course, during the Civil War, Chimborazo became synonymous with both hill and hospital.

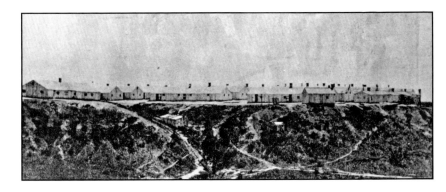

Some say that the name came with the cargo boats from South America, along with homesick mariners spinning yarns by the lee. Others say that explorers from our own City brought the name back from their adventures on high.

Perhaps... but what if? What if the name came not from a traveler but a poet? The poet Park Benjamin wrote about Mount Chimborazo in 1841. Emerson, in 1844. And Longfellow, in 1845. To them and other poets of the day, the mountain was a symbol, a metaphor about "standing out of our own low limitations" or "measuring in lofty thought the march of time."

Our very own Edgar Allan Poe ran with this same pack of poets. He edited them, competed with them, even celebrated their occasional fits of genius. And maybe, just maybe, he brought their mountain home to us. In 1849, shortly before his untimely end, Poe returned to Richmond to lecture on his "Poetic Principle." In it, he argued that "a poem deserves its title only inasmuch as it excites, by elevating the soul." How better to sell this argument than to sing a mountain out of our own little hill?

And that, my goodly readers, is how Chimborazo, the hill that tops the bend in our river, *might* have earned its name.

# Code Duello

Like other cities built on the flickering embers of human emotion, Richmond is part comedy, part drama – at times, eye-wateringly funny, at others, grief-stained and broken. No more so than in the days of the *code duello*, when men hungering for love and honor would draw pistols over the mildest insult or hint of disfavor. These were days of heroes and hotheads, bullies with pens, and swains with bruised hearts, which is to say, days not unlike our own.

For the record, dueling has been outlawed in Virginia since January 26, 1810. But finding no source in an Act of Assembly, dueling would not be silenced by one. It thrived for nearly a century to follow, abetted by impertinent young men roaming streets and newspapers in search of offense.

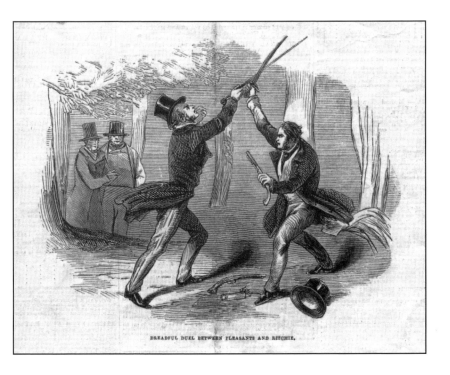

DREADFUL DUEL BETWEEN PLEASANTS AND RITCHIE.

Richmond's most famous duel of the heart took place in 1873 between McCarty and Mordecai, suitors for the delicate hand of Miss Mary Triplett. They dueled at dawn in Oakwood Cemetery, Mordecai dying from his wounds and McCarty in "broken health" for the rest of his life. Apparently redeemed by the affair, Miss Triplett married one of Mordecai's pall-bearers, but she reportedly suffered a lifetime of misfortune as her just dessert.

In the days before organized sport, newspaper "dueling de-partments" would cover each sordid affair, often in series and rarely without peculiar attention to detail. From these many published accounts, I dare offer just a few.

In the category of "most armed," consider Pleasants versus Ritchie in 1846. Pleasants reported to the field with a sword cane, two dueling pistols, a revolver and a bowie knife; Ritchie, with a Roman sword and seven pistols. As if to prove that life is neither fair nor congruent, Pleasants was mortally wounded while Ritchie, who provoked the duel, was acquitted of murder but died of remorse just a few years later, leaving his entire estate to Pleasants' daughter.

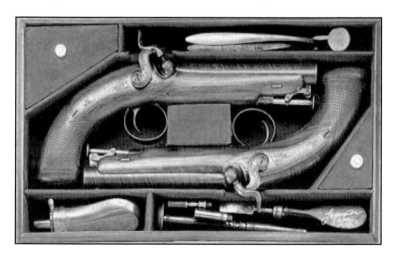

# Code Duello

In the category of "nearly flummoxed," consider Aylett versus Wise in 1859. Their duel was suspended for days as they quibbled over the terms of engagement. At issue was the line of position, proffered by Wise's second as "perpendicular to the line of the light." This occasioned a series of letters with conflicting interpretations, nearly all of them published, some as remote as the *New York Times*. Happily, the duel proceeded but ended bloodless despite better intentions.

Many other duels bear mention – duels over candles or whiskey or women; duels between nearsighted gray-hairs and wild-eyed youngsters; even a duel involving our prodigal son, Edgar Allan Poe, who managed to distract his opponent with a most improbable tale, after which they repaired to a local tavern to toast their respective health.

It may be impolitic to revive the *code duello* in these modern times, to suggest that our more outrageous politicians and other hotheads take to the dueling fields with their seconds and give the rest of us some peace. But just think – what if we could arm their bullying *ideas* with pistols and dispatch them all to the unforgiving line of dawn's first light?

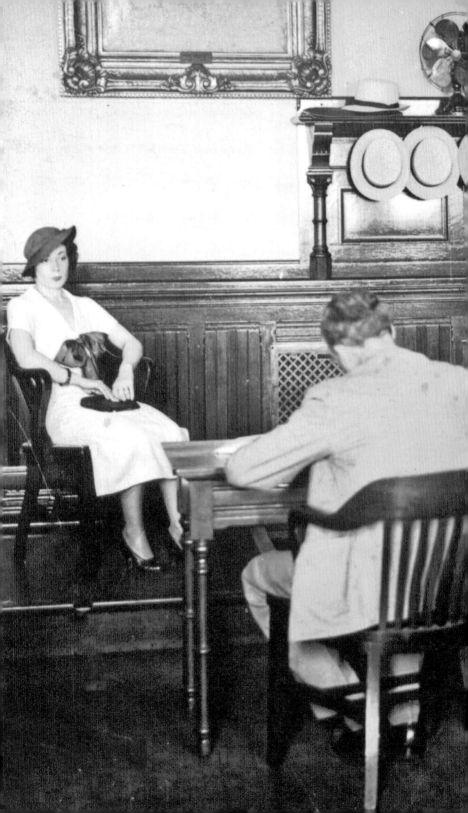

# Desperados

In every boy's life, the delights of Piglet and Pooh cede to the dangers of cop and robber, to the clarity of contrasts, of good versus evil and rapscallion versus brave knight. And while no moral has ever been drawn from villainy, sometimes the villain needs to be exposed for his insolence lest little boys follow too quickly in his footsteps. After all, crime never pays.

Happily, Richmond can lay no claim to the gangland glamour or violence of Chicago or New York. But for a time, Richmond was besieged by thugs who by their audacity became legends.

On March 2, 1934, Robert Mais and Walter Legenza hit Richmond like a pair of concrete galoshes. They held-up a bank, ambushed a mail truck, and lived by wits and guns for months before being held to account.

Their preferred get-away car was a Hupmobile sedan with artillery-style wheels. And their lady luck was Lenore Gosslyn Fontaine, a "petite French Canadian girl with an arch-twinkle in her eye."

Even after being caught and tried for their string of crimes, our two desperados enjoyed a brief reprieve at the hands of Mais' mother, who managed to smuggle two pistols into the Richmond City Jail in a can of baked chicken. So armed, Mais and Legenza staged a daring escape, eventually thumbing their way up Highway 301 to the relative safety of Baltimore.

On the run but not out of mind, Mais and Legenza made headlines throughout the fall of 1934. They even upstaged the World Series for banner coverage. On October 4, day two of the Cards versus Detroit, our escaped bandits were rumored to be cornered in either the mountains of Southwest Virginia or the creeks of the Northern Neck, with shop-keeps in both places reporting their duplicitous purchases of milk, matches, soda crackers, and Stud tobacco.

But in the end, justice exacted her price, and our thugs met with the executioner's chair. On their death walk, one of them was asked by a guard what he wanted done with the 22 cents in his pocket. Ever a thug, he replied, "Oh, keep it and buy yourself a battleship."

> So boys out there, grow straight and true,
> and follow our righteous men in blue.
> And girls stray not for men in black,
> for they'll soon be gone and never come back.
> And mothers, dear mothers, teach them to holler,
> that a cold can of chicken is sweeter than a gangster dollar.

*Note: In 1934, when Mais and Legenza were successfully avoiding capture, Frank Dementi was serving as a photographer for the Richmond newspapers. According to local legend, what led the FBI to capture the two desperados was an anonymous tip from a reporter. Over the years, Frank's contention was that he, indeed, was that reporter. Having heard that the two outlaws were holed up in the Church Hill section of Richmond, Frank claimed that he entered another house in the immediate vicinity, spotted the pair through a window at the same level as their apartment, and telephoned the FBI to report their whereabouts. Son Wayne Dementi remembers that when the TV series, "The Untouchables," aired an episode about Mais and Legenza in the 1960s, he watched with his father, who was indeed vindicated when the television version of the capture of the two wanted criminals closely paralleled Frank's recollections. We are pleased to permit some of Frank's photos of the trial of Mais and Legenza to accompany this essay.*
> *Frank's sons, Brian Dementi and Wayne Dementi*

# Southside

The James is our life force, our tangle of wildness out of which rises prehistoric fish with scutes instead of scales, giant crags of granite speckled with feldspar, and the jumbled tweets and trills of our many fine-feathered friends. Just south of the river is the proverbial "end of the line," once a fairyland estate, then a penny arcade, and now an urban oasis of woodlands and creeks known as Forest Hill Park.

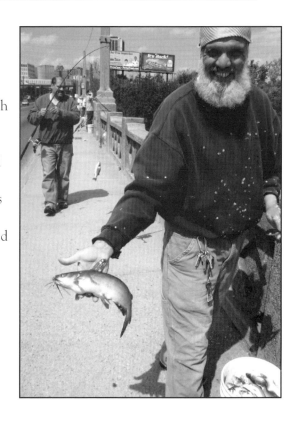

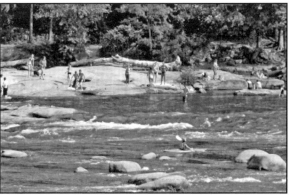

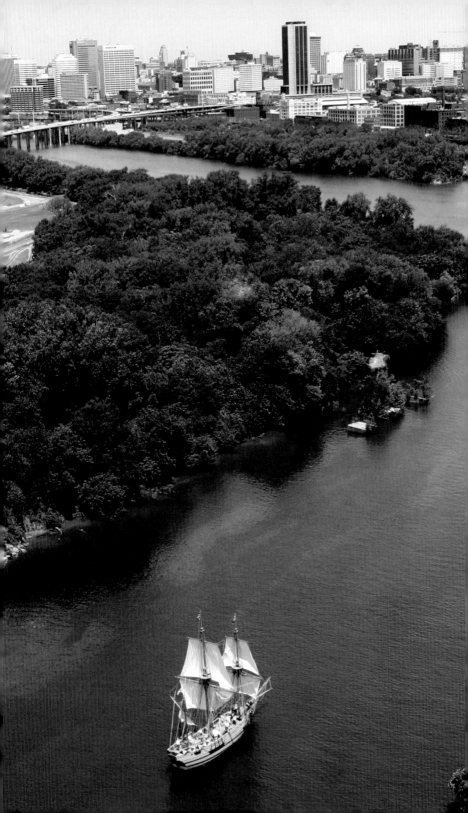

# The Mighty James

Richmond is a tangle of life, noise, and energy heaped layer by layer upon the shadows of the past. It is in equal measure a crossroads, a destination, and a point of departure. And it is in nearly every respect a reflection of the river that courses through it.

The James River is 600 million years old, 340 miles long, and exists from headwater to mouth entirely within the Commonwealth of Virginia. It drains a watershed of 10,000 square miles, sustains more than 2.5 million people, and is home to more critters and wild things than we city-dwellers may care to imagine.

Richmond sits beside the Falls of the James, a natural escalator that extends from Georgia to New Jersey. Within this fall zone, the river plummets more than 100 feet in

elevation in just a few miles. The zone is more than a geophysical oddity. It serves as a very real, natural barrier against westward migration, at least by boat.

Of course, the James was not always the James. For most of its 600 million birthdays, it probably had no name at all. Our own native people called it the Powhatan, at least for a while, in honor of the chieftain who ruled over the tribes of Tidewater and the Coastal Plain. Captain John Smith renamed the river in honor of James I, King of England, in 1607, and we have known it by that name ever since.

There are at least 138 tributaries of the James that ramble like vines through the capital region, some with common names like Little, Broad, and Deep, others with exotic ones like Whippernock and Pocoshock. Through rills and backwaters, roils and backeddies, riffles and bends, the river tumbles life into even the most remote and inaccessible of our backyards.

# The Mighty James

We have been drawing from the James since our earliest days, devising new and better ways to fish and tame and tap her along the way. We may not have sanctified or deified her like the river gods of ancient Greece, but still we have looked to her as a place of wonderment, introspection, adventure, and renewal.

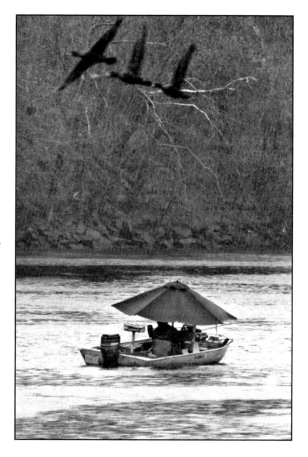

There is a well-worn fable about a dog that comes to a river crossing with a tasty bone in his mouth. As he gazes into the river, he sees what appears to be another dog clutching an even bigger bone. After a few measures of comparison, the greedy dog drops his bone and lunges for the bigger one, realizing too late that he has assaulted his own shadow.

The James River mirrors the life, noise, and energy of the City. She sparkles with the promise of future glory, but we should be thoughtful about our demands, or like the greedy dog, we may end up with nothing.

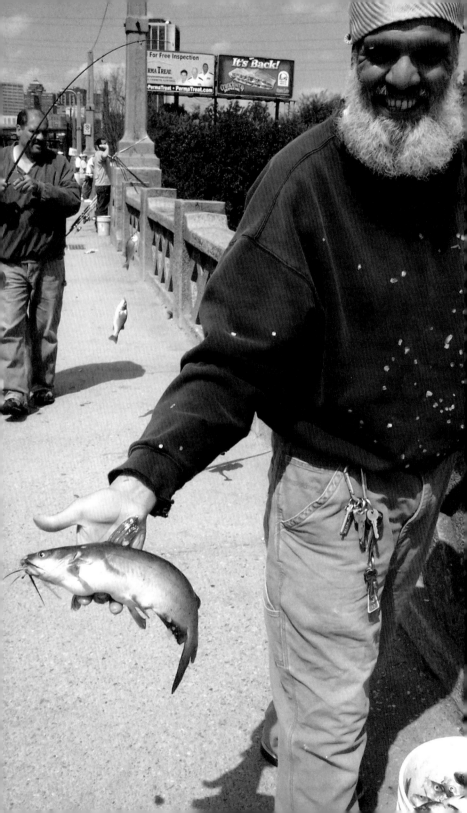

# Tall Tale

They call these the "turtle days" of winter – days to recede into our shells and contemplate the what-ifs and what-nexts, the would-haves and could-haves, and a dozen other impossibilities that may yet draw us from our imperturbable paths. With apologies to you winter-lovers out there, these are days to dream of spring and her mind-rush of renewal, of willow catkins, fern fronds, shad, and baseball. But however singular our dream may be, it is no match for the one lurking in the depths of the Atlantic, awaiting that primal urge to come home.

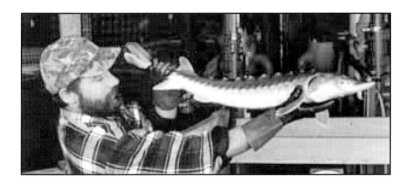

Sturgeon are the oldest living residents of Richmond. Their fore-fishes swam with dinosaurs 120 million years ago, amidst astrodons and sauraposeidons and all manner of gigantic armored beasts. They return home to the natal freshwaters of the James River every spring to spawn and play and make mischief, and for that we may be the luckiest City in America.

Sturgeon can be massive – up to 14-feet long and 800 pounds – with scutes intead of scales, whiskers called barbles, and eyes of golden iris. In the time of Captain John Smith, there are accounts of brave-hearted natives who would lasso sturgeon by the tail and then hang on for sport or dear life.

Sturgeon have the inexplicable habit of jumping clear out of the water. Some say they breach as a form of communication, as if to say, "Hey, there's a nice cold spot over here." Others, to knock off bugs, or take in air, or just for play. Whatever the reason, a leaping sturgeon is an unforgettable sight, and occasionally hazardous. One of George Washington's generals reportedly died from wounds suffered when a sturgeon leapt into his boat. And just a few years ago, a woman down south a'ways suffered five broken ribs from an uppity teenage sturgeon.

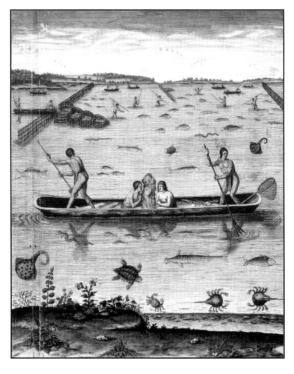

As with many natural wonders, our zeal for possession almost extinguished our fine snout-nosed friends. We fished them for their fluffy boneless meat, for their delectable caviar, for bookbinding, and for isinglass – that clear, natural gelatin used for wine, jelly, and carriage windows.

We took them to the brink, and yet now, as if in a dream, they are beginning to return. Just last year, a five-footer jumped into the lap of an unsuspecting fisherman down around Osborne Landing, and the accounts of prodigious jumpers made headlines long into our Indian summer.

So as you tuck yourself into the turtle shell of winter, as you dream that old dream of what-ifs and what-nexts, pray dream a little dream of a sturgeon spring, of that ancient fish return-ing from the depths of the ocean to her natal river, our natal river, to spawn and play and make mischief before a City with eyes wide with wonder.

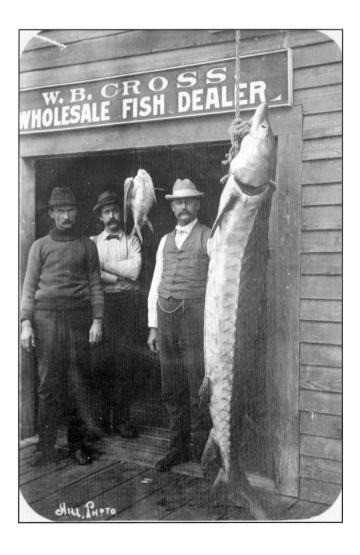

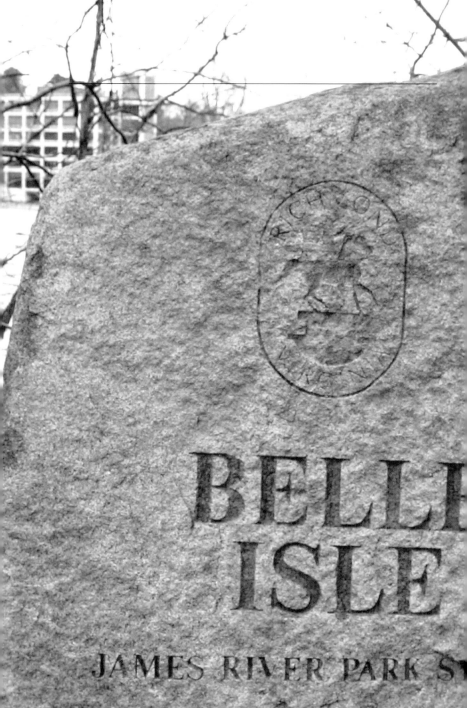

RICHMOND VIRGINIA

BELLE
ISLE

JAMES RIVER PARK SY

# Belle Isle

*C*ome said the Muse. There is a place wild and hallowed, where you can dip your feet into the mighty James, wiggle your toes, watch the clouds drift by, and let your ears wander to the soothing mumbles of the river.

Belle Isle surely started wild, amidst a vast pluton of molten rock that hardened to form giant crags of granite speckled with feldspar, hornblend, and quartz. The island emerged in the shape of a teardrop, a half-mile long and a third-mile wide, with a bluff high enough to rival any of the famed "seven hills" of Richmond.

William Byrd I was the first western owner of the island, tucked within an estate known as "The Falls." Then came Byrd II, who remarked, apparently with relish, that the noise of the river from the island was loud enough to drown out the notes of a scolding wife. And then Byrd III, the luckless gambler who was forced to sell the island as lot number 322 in a private land lottery intended to redeem his gambling debts. After the Byrds, the island passed from owner to owner, among them, Bushrod Washington, a United States Supreme Court Justice, and "Light Horse Harry" Lee, the celebrated Revolutionary War hero and governor.

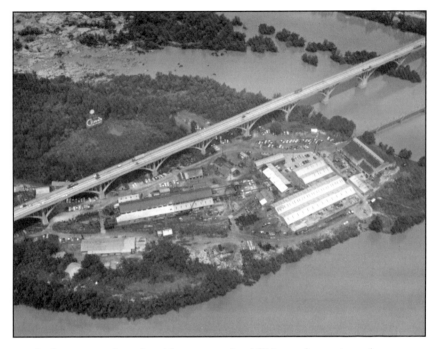

Industry on the island began in the 1830s and continued, with only one interruption, for 140 years. Over that time, the development and use of the island was intense, including rolling mills, keg factories, sawmills, furnaces, quarries, a hydroelectric dam, and during World War II, a tank factory. Amazingly, these activities actually changed the course of the river – from south of the island to north.

The one interruption to industry, of course, was the American Civil War, during which time the island was used as a prison camp and cemetery for Union soldiers. Notorious for its grim conditions, this prison returned a line of men after the war so reduced as to prompt the poet Walt Whitman to question, "Can these be men?"

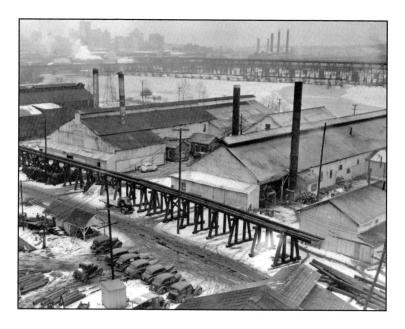

Industry on the island ended in 1972, when the City purchased the property for a park and allowed it to settle back into relative wildness. Today, the ruins of the old factories crumble under creeping vines, the quarries run with water, and earthen mounds mark the edges of the old prison camp.

Belle Isle is the jewel of the James River park system, a favorite among paddlers and bikers, runners and hikers, waders and recliners, poets, crooners, and the great washed and unwashed masses of the City - which is to say nearly all of us. And it is surely a wild place, with "billows of rocks" and "great craggy stones" and dangling greens and all manner of critters. But it is hallowed too, and this, I think, is the Muse's call. *Come, she said, come see the past reclaimed, just so.*

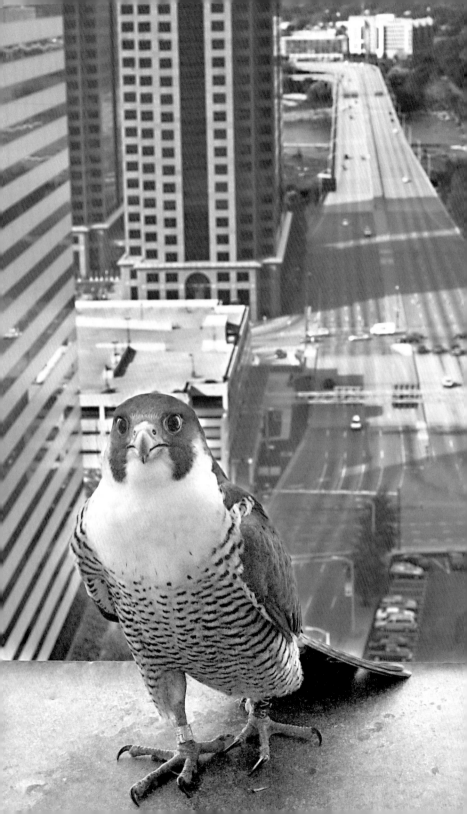

# For the Birds

Our City is for the birds – literally.  Richmond is home to over 300 species of winged warblers.  They mottle our landscape, diffuse our soundscape, and at the break of day, their jumbled tweets and trills are like a rhapsody.

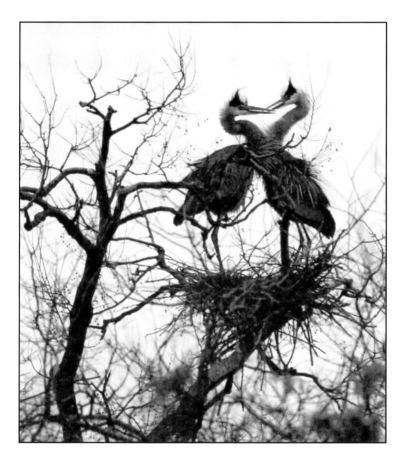

We have Pewees in our uplands, Flickers in our lowlands, Chats in the meadows, and Least Bitterns in the swamps. We even have Peregrine Falcons, once believed extinct, nesting in the City's business district and stooping for prey as if our glass towers were old-growth trees.

Where there are birds, there are birders. And whether from backyard or backwater marsh, our City's birders posted more checklists last year than nearly any other place in the nation. We recorded over 2,000 Grackles, those immodest black-birds with creaky voices like rusty swings. And nearly 1,300 Dark-eyed Juncos, those Napoleonic sparrows who peck their subordinates and rush their foes with extended necks and nodding bills.

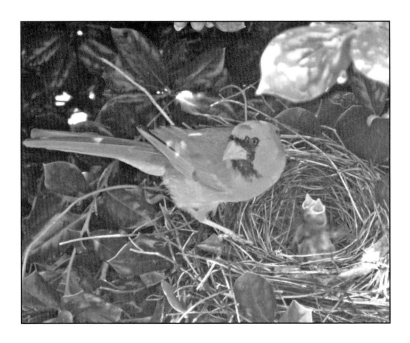

If life imitates art, then surely birds imitate humans. But their role play is not all mockery. Richmond is refuge to Killdeer, precocious little shorebirds whose babies emerge from their eggs in a sprint. Mother Killdeer often fake injury to draw intruders away from their nests, dragging their broken wings woefully along the ground until they reach a safe distance, then instantly healing and in flight, their song "kill-dee, kill-dee" marking each successful pantomime.

# For the Birds

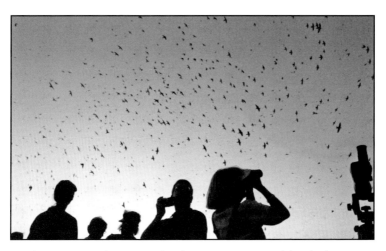

And our Capital City is also home to a capital bird, the Cardinal, who lives a life we can only hope to imitate. Cardinals always come in pairs, they sing together before nesting, they scurry around to protect their nest, and they take turns feeding their babies. No wonder their call is "cheer, cheer, cheer, what, what, what!"

Yes, Richmond is like a sanatorium for noisy songbirds, for Loons and Cormorants, Larks and Cuckoos. My own little towheaded birds begin each day with pail and bucket, digging wide-eyed for worms. And in this world-wide measure of grief for our beloved Hokies, I am beginning to think that we all need to learn some rhapsody from our fine-feathered friends.

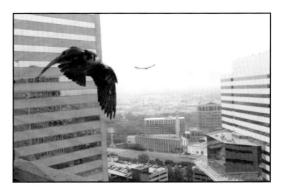

*Note: This essay first aired on April 27, 2007, in the wake of the tragedy at Virginia Tech.*

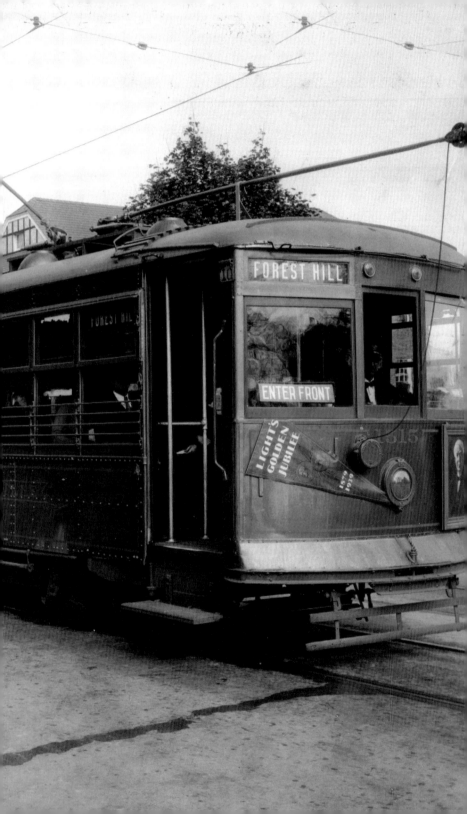

# The End of the Line

Every so often, if you're lucky and eat your greens and smile at passing dogs, darkness will turn to light and the wildest, most whimsical and irregular inspiration will descend upon you, at which point, if you're smart and well rested, you'll grab hold and ride for dear life. Perhaps you already know this, but Richmond – our dear, quixotic Richmond, City of Muses and minstrels and mislaid bricks – has seen the light not less than twice.

The first spark of inspiration came in 1887, when our City fathers hired Frank Julian Sprague to build the nation's first electric streetcar system – one capable of taming the wild and rutted hills of Richmond. Sprague delivered, and his system went into service on May 4, 1888, connecting the City with its most distant wards and opening the proverbial door for so-called streetcar suburbs in all directions.

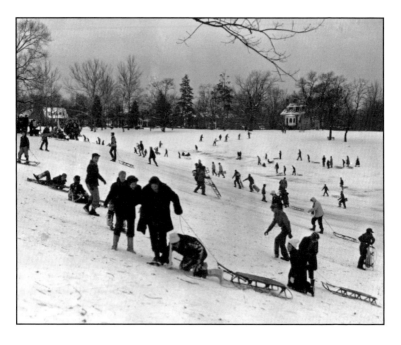

One such suburb was the sprawling green-scape south of the river, past Manchester and through Woodland Heights to the fairyland estate known as Boscobel, from the Italian *bosco bella* or beautiful woods. The savvy streetcar operators saw opportunity at the end of the line, and made Boscobel the City's amusement destination of choice, replete with a bandstand, carousel, dip-to-dip roller coaster, laughing gallery, enchanted house, dance pavilion, and penny arcade, all tucked neatly within an outdoor paradise of woodlands and creeks, a lake and trails, and even a meadow for picnics and naps.

Real estate prospectors soon joined the act, luring buyers down the streetcar line with nearly too-good-to-be-true advertisements like: "This is not properly a park in the general accepted idea of parks. It is more a fragment of the widest mountain scenery… one of the most beautiful and picturesque bits of earth to be found anywhere."

# The End of the Line

And so went the second spark of inspiration – 5 cents a fare to get there, and 50 cents to get in, with ladies admitted free on Wednesdays and half-price the rest of the week. Surely no bygone image of Richmond is complete without some scene from Boscobel – sledding on a winter day, or hunting for eggs around Easter, or tossing darts for prize and glory.

Sadly, nothing lasts forever, not peppermint clouds, nor flying elephants, nor even the sparks of inspiration that gave our fair metropolis the streetcar and Boscobel. The end of the line for the amusement park came in 1925. The streetcar clanged along for another two decades but eventually ceded to its unshackled sister, the bus, in 1949.

When the light fades, if you're lucky, a few morsels from the feast will remain. In 1933, Boscobel was deeded to the City and became Forest Hill Park. Even now it remains an urban oasis of woodlands and creeks. And though the penny arcade is long gone, the meadow still beckons to latter-day Muses and minstrels for afternoon naps filled with the most whimsical and irregular of dreams. I hope to find you there!

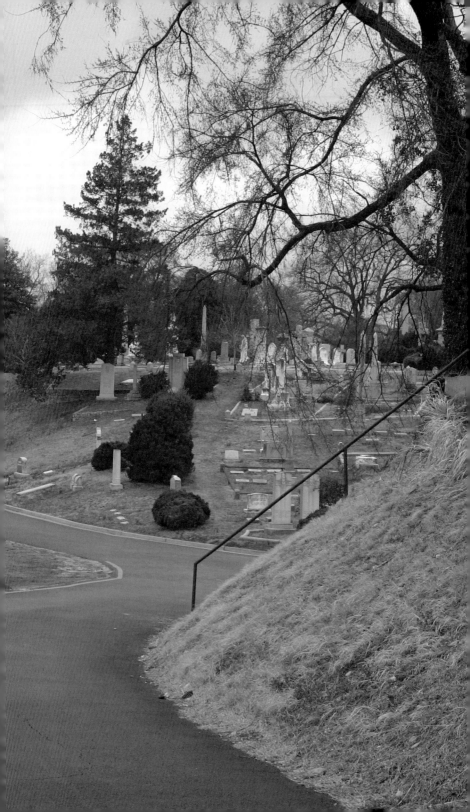

# West End

Once upon a time, the west end boasted a castle; fiery hill-dwellers rumored to be disciples of Vulcan; China Tea roses; elephants, circus tents, and a Chinese pagoda; and three-winged butterflies on teeter-totters. These old stories may seem like make-believe now, but you can still catch their scent by meandering the little neighborhoods that radiate west from the City center like a fan. And if you find your-self catching your breath in one of the many triangle parks formed by the fan-effect, even better. After all, *it don't mean a thing if you ain't got that swing.*

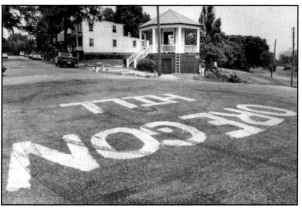

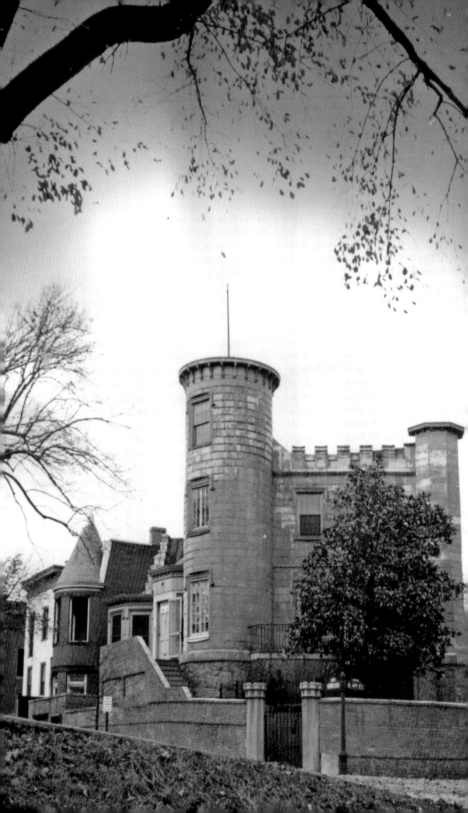

# Pratt's Folly

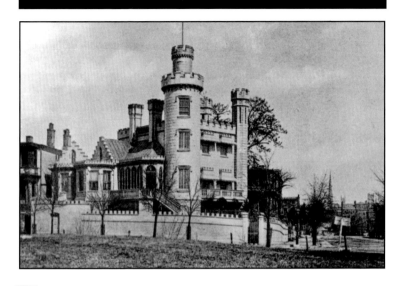

Once upon a time, many years ago, the world was a story-book of fair maidens, and brave knights, and destiny branded by fire-breathing but gentle and entirely misunderstood dragons. Oh, and castles too, great big stone heaps of castles, from which trumpets would blare at all times of day and night to the chagrin of Mrs. Castle Owner's more decorous neighbors.

You may think that these stories all unfolded far, far away, but 'tis not so. We had our own castle right here in Richmond. And while no maiden ever spun gold or let down her hair from the looming turret within a turret atop our castle, still its stories may rival those of the Brothers Grimm.

Our castle was built by William A. Pratt in 1853. And he gave his stone heap all the whim and fancy of a fairy tale. He also gave it all his hard-earned money, which is why it was known, in equal measure, as Pratt's Castle and Pratt's Folly.

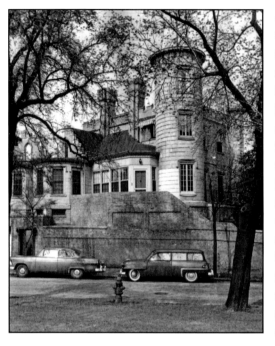

Among its distinctions, the castle had a hidden "half-way room" between the first and second floors. It also had a dungeon, which was forgotten but then unearthed when a latter-day owner tried to replace a water pipe. The castle sat on Gamble's Hill, and from a tiny room in the looming turret, accessible by spiral, wrought iron stairs with pirate's rope for railing, both maidens and knights could enjoy the finest view of Richmond anywhere in the City. And down below, deep under the hill, they could follow a secret tunnel to the river, a lovers' passage that later fell into the desperate hands of rum-runners and thugs.

As with any good castle, Pratt's Folly was haunted, and not just for Halloween. The haunt was known as the Red Devil, and he was surely better than any modern-day security system to keep ill-doers at bay. If haunts shadow fact, then the Red Devil may have been Pratt's real-life successor, an old sea captain who went insane from the firmness of the ground and was known to race madly through the yard within the battlement of the castle clad only in red flannel underwear.

# Pratt's Folly

The castle was rumored to be magic too, courtesy of a wishing box hidden under the living room floor. For many years, visitors delighted in offering their wishes to this box, under house rules that read as follows: "Don't wish for the moon. Don't tell what you wish. And if you borrow the coin to make your wish, be sure to pay it back."

Alas, like any castle, ours fell into disrepair, narrowly surviving fires in 1945 and 1951. By 1955, it was rentable, in full, for the pauper's sum of $455 per month. A few years later, it was torn down to the shock of preservationists near and far.

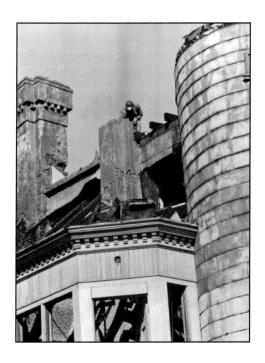

We may no longer have a castle, but we have its stories. And we should tell them loudly, like trumpeters from the turrets, for the delight of our children and the chagrin of our more decorous neighbors.

# True Grit

Oregon Hill is a changeless place, as remote and inaccessible as its namesake in the Pacific Northwest, as gritty and determined as the laborers who once cut their paths to the factories along the river, and as precious as the antique China Tea Roses that creep and crawl their way up the pitted iron fences surrounding Hollywood Cemetery.

If this singular hill could talk, it might declare with baleful eyes that tomorrow it will clean and scrub and settle itself into a well-behaved neighborhood. But tonight, just for a time, it must ponder the sky, and make mischief of one kind or another, and wait to see what the moon brings home.

Nearly 20 years ago, Oregon Hill was added to the National Register of Historic Places as a "remarkable example of an intact nineteenth and twentieth century working class neighborhood." This listing heralded the blue collar roots of the hill, miraculously "preserved intact both by its isolation from the rest of the city and by the determination of its inhabitants." But the listing was not news so much as validation. As early as 1856, Richmond's favorite old citizen, Samuel Mordecai, described these hill-dwellers as a "hardy and industrious and fiery race, disciples of Vulcan."

Without question, the patchwork of European immigrants who made the hill home was determined. And without further question, their descendents have preserved this determination with pluck and pride. But this is only one view of the hill. Here are three more.

First, the hill is under the protectorate of a nearly forgotten saint, Grace Arents. Within the confines of the hill, Grace helped to establish the first free library in the City, the first supervised public playground, the first night school, the first housing project for aspiring workers, and the celebrated Episcopal school, mission, and church of St. Andrews.

Second, the hill is home to the last standing structure built, owned, and occupied by a free black man, John "Jack" Miller, Sr., *before* the Civil War. Miller, was a barrel maker who painstakingly saved his dollar-a-day wages until he had enough to buy a lot on South Cherry Street and build a cottage of hand-split lath for his family.

Third, the hill has endured every slice and cut of the Downtown Expressway, affectionately known from within as "that big ditch." On July 29, 1971, the Expressway forced down the old fire bell at Engine Company No. 6, a bell that for over 86 years signaled work, school, supper, and play for the goodly residents of Oregon Hill.

The bell may be gone, but the pulse of energy abides like those China Tea Roses in Hollywood.

Steinbeck once offered us the spiritual gradations of a jug of wine: first serious and concentrated, then sweetly sad, then on to thoughts of old loves, then general and undirected despondency, then songs of redemption, and finally, a point from which no certainty could be measured, and anything could happen. This is not unlike watching the moon from Oregon Hill. Go on, who knows what the night will bring?

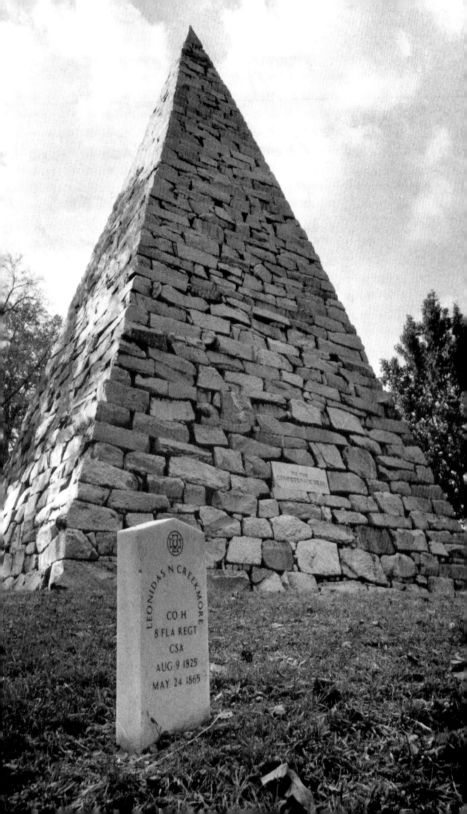

LEONIDAS N CREEKMORE

CO H
8 FLA REGT
CSA

AUG 9 1825
MAY 24 1865

# Hollywood

**H**ave you ever found yourself awakened into one of those perfect days, when the sun slants into the room just so, and the birds chirp away with noisy abandon, and the trees swish their arms in unison with an un-harnessed wind, and you think to yourself (or maybe even aloud) how lucky you are to be here in this place at this time, and all of the perturbations of the world seem to fade away, and all of the wanderlust too, and it is just you and the world?

What do you do when presented with such an awakening? Call in sick and revel in the slant of the sun, chirp with the birds, or climb those happily humming trees? Surely all good choices. I will profess no certain qualification in such matters other than the occasional good fortune of a perfect day, in fact, as recently as yesterday. So what did I do?

Well, I ventured down the street to the cemetery known as Hollywood, and I rambled her rambling goose-step alleys, and paused to consider her many symbols, the stillness of her grounds, and

the peace too. After a time, I came to her bluff overlooking the river, and I stood with the old whale bones on the hill looking down at the scoured rocks, the little eddies and pools, the rills and rapids, and for a moment I felt as if the river was tumbling up at me, even though I knew it could not be so. And more than anything, I felt grateful to be meandering like the mighty James instead of being fixed in place like the mighty old ghosts around me.

I paused to admire their names: the great architects of the City, Mayo, Haxall, Ginter, and Arents; her students, poets, and writers, Freeman, Glasgow, Cabell, Dowdey, and Tabb; her sculptor, Valentine; her tragic cavalier, Stuart; and her presidents too, Tyler, Monroe, and if he counts, Davis.

And I wandered through the maze of broken and draped columns, the crosses and the crowns, the doves and the lambs, even the iron dog and the stone pyramid, so storied as to be nearly mythic in our little City.

I found tall tales at every turn. I even found John Galt, but *who* he was remains a mystery.

This is but one way into Hollywood. And it is not so much returning to Eden as being recalled to Grace. This place, so austere and hallowed, but yet peaceful too, a place designed for recreation and leisure as much as final rest. A place of pitted iron fences and crumbling soapstone, hollies and me-andering dales, a long-spent old spring, and antique roses too, roses that would have been common during the cemetery's first burial in 1849: Red Smith's Parrish, Mrs. R. B. Cant, Buff Apricot, Old Blushing, Bermuda Mystery, China Tea, Crenshaw Musk, and perhaps others too, perfect specimens of the past, crawling and creeping their way to the light, just like me.

So what would you do? What would anyone do? Why not follow Ms. Glasgow's epitaph: "Tomorrow," it reads, "to fresh woods and pastures new."

**CITY OF RICHMOND**

Monroe Park

**Parks, Recreation and Community Facilities**

WiFi zone

# Monroe Park

Follow your Muse. Follow her past kittens with parasols and tamarinds playing slide trombones. Follow her from the songs that are to those that once were, to the songs that abide in the shadows of Richmond's past. Follow her to Monroe Park, the Grande Dame of Belvidere. Promenade, smell the flowers, take in the air, or just sit awhile.

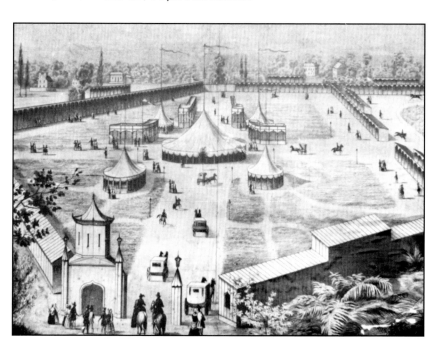

Monroe Park is our City's first public green-space, platted as Western Square in 1851. For a time before the Civil War, the park served as grounds for the State Fair of Virginia, replete with elephants and circus tents and even a Chinese pagoda. The circus tents gave way to a military hospital during the war, then ashes and sandlot baseball. In 1869, our City fathers adorned the park with a massive fountain and radial paths like spokes on a bicycle wheel.

# Monroe Park

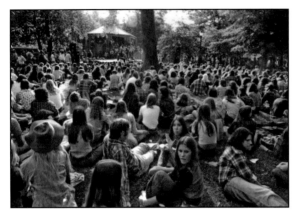

The park originally boasted 26 varieties of tree, mostly highland hardwoods with high canopies for better sight lines. She had partier gardens and gas lights, central park settees and goosefeet alleys. She was, in nearly every respect, Richmond's Hyde Park. But years of hard use left her diminished. High canopies gave way to dense evergreens, and coarse rock paths to asphalt. On her centennial, she was almost denuded for a parking lot. But she was reprieved through the sustained fight of neighbors and newspaper editors.

Monroe Park abides. She is not what she once was. She has had a hard-scrabble past. But she remains a place of grassy plats and clover, lovelorn coeds, crooners, and beatnik poets. The fountain still rains down, and the bells still toll from the monumental churches that ring her perimeter.

Our park roots date back to the first days of hubbub, when City planners had the foresight to set aside places for contemplation, for quietude, places where even the working poor could gather for a day of rest, and picnics, and promenades. We are now deep into hubbub, so deep that it literally zaps the air with digital tumult. And we have new ways to escape, new access to far-away places more tantalizing than the local green-space.

But we still need her, our old Monroe Park. We need the tonic of her shapes and hues, the repose of her scattered memorials. And she needs us too. She needs to be more than a wayside for itinerant students or shelter for our City's homeless. Every now and again, she needs to smell the powder of fireworks, taste the flow of wine from a lovers' picnic, hear the peace rallies and gypsy guitars, and dance with little girls in pinafores. Follow your Muse, and she'll lead you straight to the fountain at the center of Monroe Park. Remember, she could have been a parking lot.

# Playgrounds

Not so long ago, in a far off land, there lived a little girl, or boy, or three-winged butterfly, or some other preposterous thing, and each reveled and romped, tumbled down hills, hid in tree stumps, and exuded joyful chaos unto the world. It was a time of high adventure, imaginary friends, and great perturbation over naps, green beans, and rainy days. And, above all, it was a time of reckless faith in the goodness of play.

Not dally or diversion, but play of deliciously spontaneous commotion, of swings and slides and teeter-tot- ters, of little ones spin- ning wildly into and out of circles, of scuffed shins and sandy drawers. Play so earnest  as to suspend dinner, bedtime, maybe even the course of human events, in the sun-specked garden of childhood.

There are so few three-winged butterflies these days that the old stories may sound like make-believe. But their words echo in the playgrounds of the City, in the mysterious pocket parks that whis- per nursery rhymes from the alleys of the Fan District, and in

the tot lots and tricycle gardens that anchor nearly every neighborhood of our little metropolis.

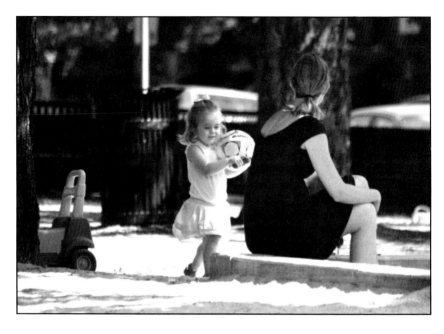

There are 83 public playgrounds in the City alone, with improbable names like Paradise, Scuffletown, and Petronious Jones. There are hundreds of others run by schools and daycares, homeowners associations, and grown-ups with the hearts of children. Sadly, there are no reliable statistics by which to compare our playgrounds to those in other cities, but surely we rank at the top in both noise and number.

My favorite is Lombardy Park, a tangle of misfit toys, creaking swings, and monkey bars bordered on three sides by urban civility. It is nearly always teeming with children, their eyes wide with wonderment over the spectacle of a one-wheeled wagon or a bottomless pail. But it is best at the first light of dawn, when even a discerning adult is free to slide and swing and exude joyful chaos unto the waking world.

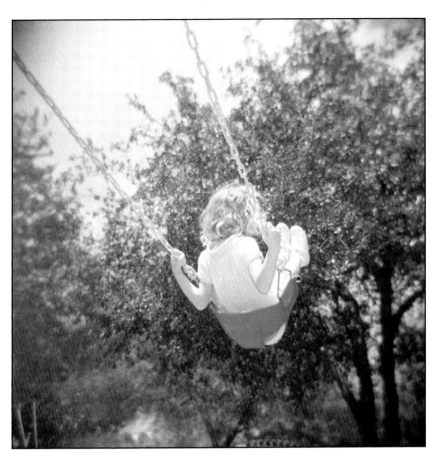

Richmond is a City of important, austere things, but it is also a City of playgrounds. And no matter how late you are for work, the impulse to stop by the park should never be compromised. After all, *it don't mean a thing if you ain't got that swing.*

# Afterword: In the Eyes of Adventurers

For some of us, it is the tug of adventure. For others, it is the clutter in the closet, physical or otherwise. But whatever the seed, we occasionally flee our nests in search of the unusual, or the tranquil, or the relatives of comparison. And oddly enough, the simple act of getting away does wonders to sate wanderlust and clear the mind. But why? Why do we need to inspect the pitch of a foreign roof before we find contentment under our own? Why leave at all? Why not vacation right here at home?

Admittedly, this borders on heresy. But just think about what it would be like to explore Richmond through the eyes of an adventurer. Imagine the stories we'd tell.

If you visited Richmond in the early days, you would have been consumed by the quality and profusion of our horses. "Indubitably the finest... in America," claimed Dr. Johann Schopf, the famed Hessian surgeon, in 1783. "One could almost fancy it was an Arabian village; there were to be seen the whole day long saddled horses at every turn, and a swarming of riders in the... streets."

Beyond horses, you may have bristled at our selective lawlessness. As one French nobleman observed in 1796, "gaming was our ruling passion; at pharo, dice, billiards, at every imaginable game of hazard, we lost considerable sums."

# — Afterword: In the Eyes of Adventurers —

And though we had strictly outlawed these vices, even a visitor could discern that our lawmakers were among the most unremitting of our lawbreakers.

You may also have noticed, out of the teensiest corner of your eye, a tinge of muddled mint, and sugar, and bourbon in the visage of your host. As many more than one visitor observed over the years, Richmonders drank and dozed luxuriously. Said one, "all the scenery in the world – rocks that Salvator would love to paint, and skies that Claude could never limn – avail not to keep [a Richmonder] away from a julep on a hot summer day."

But the keenest observer would also have noticed a proud and sensitive population peculiar in its obsession for history; an old City, nearly mythic, with storylines running deep into the braided channel of the James River; a City of ideas, more like a state of mind than a place.

Oh, to be that visitor! To get away, not to some white sand beach or temple ruin but just down the street as a *resident* adventurer. To celebrate this place, not blindly, but with eyes wide to that which was, and is, and will be. Richmond is my Muse. Follow her, and you will find noise, and light, and beneath all else, uncommon beauty.

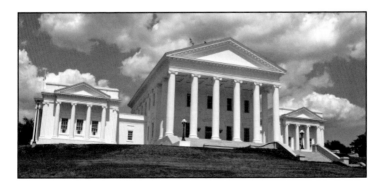

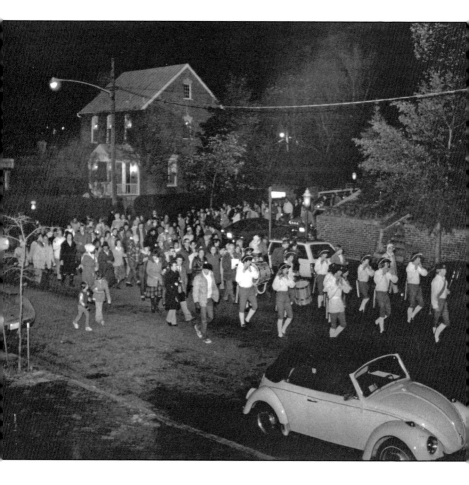

# Acknowledgements

This little book would not have emerged without the inestimable kindness of strangers, story-keepers, story-seekers, dreamers, poets, friends, and loved ones, all of whom shared in our adventure and helped us uncover the treasured old storylines of our fair City.

We owe deep gratitude to the goodly librarians and archivists of the Virginia Historical Society, **Richmond Times-Dispatch**, Richmond Public Library, Valentine Richmond History Museum, Library of Virginia, and Black History Museum, as well as WCVE Public Radio, where all of these essays first aired. Special courtesies were provided by the **Richmond Times-Dispatch**, Maryland DNR Fisheries Service, National Oceanic and Atmospheric Administration, and Yuengling for photographs used in this book.

We also bow in special tribute to Jane Dowrick and the students of the University of Richmond Osher Institute, who first inspired this collaboration; Charles Bryan, Wayne Farrar, and Tom Silvestri, for their wonderful, personal contributions to the manuscript; Brian and Pat Dementi, for their prized family photographs; Pamie Bullock, for her keen and creative eye in graphic design; Richard Page and Hart Dementi, for their wonderfully emotive photography; and last but certainly not least, Dianne Dementi and Jennifer, Emma, and Ethan Smith, for lighting our paths.

Of course, none of this would have been possible without the tonic of the parks and patches of wild left in the City, where even the most adventuring writers and photographers must sometimes pause to rest, and ponder the sky, and dream that old dream about a City born unto seven hills.

May the thrill of adventure overcome any defects of composition, and may we share a few lyrics together before the anthem ends.

# List Your Adventures

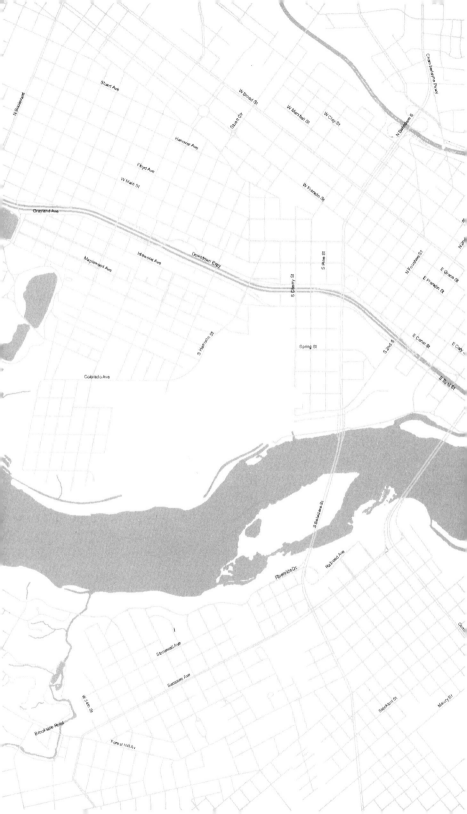